Contents

KU-637-832

Acknowledgments

Thank you to Tony my partner who has supported me and worked with me throughout the writing of this book.

I would like to thank the patients I have worked with over the years, the most important group of people to me with regards to writing this book. Without their needs I would never have developed in this way, feeling that I may have helped people's lives become a little more interesting and rewarding.

An important thank you to all the staff I have worked with, for the knowledge I have gained from their help and experience in this field of work, and their guidance in different situations, and their support getting to know and work with the client group.

Thank you, also, to the different managers I have worked for, for their faith in me, allowing me to run the pottery the way I thought best, with the freedom to develop the ideas contained in this book, developed to suit the individual needs of the people we were working with.

Ultimately, it is team work that produces the most fulfiling results for everyone's benefit.

Introduction

My main aim in this book, is to help to enrich peoples' lives through communicating methods and ideas of working with clay, in a way non-potters can follow with ease and pleasure. My main objective here is to work with, and be creative with, people with special needs. This encompasses a wide range of people.

My own pottery education began with a two-year art foundation course at the North Warwickshire College of Technology and Art, followed by a degree in ceramics at Leicester Polytechnic (now De Montfort University). This course had an industrial bias, which has been very useful in developing jigs, moulds, and various technical aids within my ceramics.

After college I established a pottery in the old storeroom of a mental hospital in Leicestershire. My position here involved working with a very wide range of people with varying illnesses, from acute to mild forms of mental illness such as pre-senile dementia, depression, schizophrenia, various phobias and so on. Being in contact with such a variety of conditions helped me to develop a new set of skills, and a deeper understanding of people. The ideas and creativity that developed in this environment were extremely interesting; many of my

own ideas have been inspired from contact with these people.

A very important aspect of such illnesses is the tendency for a person to lose their sense of self-esteem. The majority of people I have worked with had no previous experience with clay, and may have only been with me for a few weeks, so I felt it was very important that they produced something they were proud of, which had a professional appearance, and which they could then take home. Rebuilding a person's confidence is an important part of their recovery.

My next job was working for the local Council, at a day centre for adults with learning and physical disabilities. This was a very different experience, as I was enveloped in a rush of enthusiasm from people with learning disabilities who had limited motor skills and comprehension. I now had to design new ideas to suit my clientele, in order to achieve a piece of work to be proud of. The range of abilities in this group varied from quite able to very profoundly disabled, and I had to engage them all.

Working alongside people with learning disabilities were people with physical disabilities. Again this meant a variety of skills, and altogether different limitations which I had to adapt to.

In this book, I cover a number of set projects which anyone can follow. From my experience I feel that to photograph each step of the process is invaluable, as it is very easy to assume that people know what you mean, forgetting the odd little detail which can lead to someone not achieving their best results, or even having a disaster on their hands.

Throughout the chapters I will be touching on technical details, equipment and machinery, from basic commonplace items anyone can use, to equipment that a trained potter can use. Also considered is how to overcome a lack of equipment and resources. This includes how to manage without a gas or electric kiln by building a sawdust or paper kiln, in order to harden your pots off enough to make them permanent.

1. Clay and the Making Process

For those who have never touched clay before, here are some suggestions for starting, and a summary of the process. If you have clay soil, you will know well what clay is like — a very sticky substance which dries hard. It is, in fact, a sedimentary rock.

You could actually dig your own clay, then wash, sieve, model and fire it, but unless you tested it you would not know what temperature to fire it at, so I find it easier and safer to buy clay from a wholesaler who will tell you its colour, properties and its best firing temperature.

When I buy clay from my wholesaler it usually arrives in 25 kg polythene bags ready for use. It is packaged soft, maybe a little too wet for my immediate use, but it can be wedged to get it feeling right for use.

Wedging

Wedging consists of kneading the clay on a surface of wood, plaster or a concrete slab. The important part of this operation is to avoid getting air bubbles trapped to prevent pieces blowing off the pot during firing. The way to test for air bubbles is to cut through the centre of your lump of clay with a wire and open it up; if air bubbles are present you will see them immediately. You then knock the two pieces of clay back together hard to expel the air, then carry on kneading and checking for air until the clay is free of bubbles.

To keep your clay moist and pliable it is important to stop the air getting to it and drying it out. A plastic bucket with a lid, and a piece of polythene laid over the clay and tucked down the side of the clay is usually very satisfactory.

If your clay does dry out and you want to reuse it you will have to place it in a bowl, cover it with water and leave it to soak until it is soft again. This may take a few days depending on the size of lumps of clay. When your clay is soft it may be very sticky and seem unusable, so just leave it out in the air for a while and keep checking it until you can wedge it for use. This process may take from a few hours to a few days, as the conditions of damp or dry weather will affect it.

Playing with clay

Once the clay is in good condition, ready for use, try squeezing or pinching it and see what happens. How does it change shape? Does it crack at the edges? It is very liberating just to doodle in 3D, or play and take the clay to extremes; squeeze it as thin as you can, pull it apart or squash it completely flat, I could go on forever.

In my years working with people suffering from mental illness, getting them to relax and feel free to let go, to forget what society expects of them, has always been important. I have always encouraged them to do what they want, even to screwing it up afterwards if that is what they wish. Doodling and playing with clay is a very good way to start, and very often people will find themselves drawn into modelling something that looks representational, or a certain shape they have made will suggest something else and they will be inspired to go from there in a new direction.

Consistency

Clay can vary in consistency from very stiff, to very soft, and you may find you have to alter it to accommodate your client group. One woman adored modelling, from roses to clematis, to Snow White's seven dwarfs in bed. She had very weak hands from bad arthritis and operations on her knuckles. I used to get the clay as soft as I could without it being sticky, wetting the clay and keeping on wedging it until it was easy enough for her to manipulate. Some people will need much more assistance than others, in order for them to achieve their desired result.

Slip

Slip is the essential substance for joining pieces of clay together. It is just clay and water mixed together to the consistency of double cream. It should be kept in a sealed container so that it does not dry up. I keep mine in a lidded margarine pot, with a hole cut in the side of the lid for a thick brush to be kept in it. The size of brush is a matter of personal preference. However, if you are not going to be using it every day, it may be better for the brush if you keep it separately.

Once you have mixed up slip from

clay and water, you will want to keep it in this condition so it is always ready for use. If you leave the lid off overnight it soon stiffens up, so take care of your slip and you will save time.

When you are modelling and simply press two pieces of clay together they will join, and you may think that the join seems strong enough. However, when the object has dried out ready for firing it will very often fall apart at these joins, and these pieces will not stick together again when dry.

Over my years in this work I think it has been one of my greater frustrations to see work falling apart in my hands as I pack the kiln. Precious time and effort is lost by forgetting to put slip onto every joint.

Drying and Preparing for Firing

Try to make sure that there are no air bubbles trapped in the piece you have made, or sections of the pot that are more than 1 in. (2.5 cm) thick. Both of these can cause the pot to explode in the kiln, because the water and steam from the clay cannot escape. If, for example, you made a model of a head thicker than 1 in. (2.5 cm), the inside will have to be hollowed out. Sometimes, if there is trapped air, a tiny hole can be made with a potter's needle, from the air pocket through to the outer surface of the clay to allow the air from inside to escape during firing. As mentioned before, if air is trapped it will expand faster than the pot when it is heated causing it to crack or explode. It is often possible to hollow out a modelled form from underneath, where it will not be seen.

The work then needs to dry out thoroughly in a warm airy place, as if it is kept in a damp place it will be difficult to tell if it is thoroughly dry, firing a slightly damp pot will also cause a pot to break during the firing. The residue of water when heated in the kiln will turn to steam, (which occupies a larger area than water) and this expansion can blow out a piece of your pot. Drying can take anything from a few days to a week or longer depending on how thick the work is and how damp or warm the room is.

When your pot is thoroughly dry it can then be put in the kiln. The first firing is called a biscuit or bisque firing and it is possible to pack the pots touching each other (or even stacked) in the kiln at this stage. After this first firing, the pot is glazed and fired again. This is covered in detail under Packing and Firing Kilns, (see p.27).

Here is a short summary of the whole process
• Wedging (not necessary if clay is straight from the bag)
• Making
• Drying
• First firing (Biscuit firing)
• Glazing
• Second Firing (Glaze firing)

2. Tools and Equipment

Small Tools

This chapter is basically an index of tools, explaining those tools mentioned throughout the book. All these items can be bought from pottery suppliers (see list on p.126), however, many small tools can be made, and often it is better to make them to suit your own and your groups' needs. I have often had to modify and make tools to enable a person to overcome their particular disabilities, for instance using leverage to increase strength, or making things more stable and steady to help give control to a shaky arm or hand.

The Wire
The wire is used for cutting pieces of clay and cutting a pot off the wheelhead. It is similar to a cheese wire and has a small wooden handle at each end, each about 2 to 3 in. (5 to 8 cm) long and ½ in. (1¼ cm) wide.

Cutting Knife
Cutting knives can be bought from any pottery supplier and have a wooden or plastic handle. Alternatively you can make your own. I have used a hacksaw blade for years — a piece of broken blade over 6 in. (15 cm) long, with the teeth ground off and a point at one end. It makes a really nimble little knife, and the edges do not have to be sharp to cut soft or leatherhard clay. I have included a diagram of the angle needed when you grind, or find someone to grind, your knife into shape.

Dart

An old dart is a very useful tool, and I have found that for some people who cannot use a knife, a dart can be used for cutting soft slabs of clay as well as for drawing into the surface of the work. Similar to this, though not as strong, is a potter's needle.

Paintbrush

Apart from its obvious use for painting on glaze, I always seem to be using a paintbrush for one thing or another. It is good for tidying up the areas where we have been using slip, and for getting into small spaces, or for working on a joint that is awkward to get at.

Rolling Pin

A wooden rolling pin is best for making slabs, and when it gets layers of soft clay built up on it the best way to clean it is with an old credit card or phone card. You curve the card round the pin at a slight angle away from it and scrape down the pin. Do not wash the pin during use as it takes a while to dry out properly and will stick to the clay if wet.

Wooden Slats

These strips of wood are very good for making slabs of an even thickness when rolling. A couple of strips of ordinary hardboard provide a good thickness for rolling delicate shapes like rose leaves, and ¼ in. (6mm) strips are good for general slab work, ½ in. (12 mm) strips may be needed for work that calls for quite substantial slabs of clay.

Kidneys

These are kidney-shaped pieces of rubber or metal, about 3½ in. in length. They are used to scrape the surface of pots to produce a smooth finish; the rubber ones are for sieving wet glazes. It is very easy to make your own by cutting an old credit card into the right shape.

Kitchen Sieve

This is excellent for making hair, grass or texture on your hand modelling. (*See* the Sheep and Hedgehog Project.)

Garlic Press

Another very good gadget for making hair or grass.

Sponges

I use large household sponges for cleaning up and sponging

the rough edges of pots. They can also be cut down to the size you require, and into simple shapes such as triangles, circles, squares or flowers, for sponging glaze patterns on to the pot. Natural sponges can be used but are a lot more expensive.

Modelling Tools

These are specialist tools from Pottery Suppliers. These can be small boxwood tools that come with a selection of differently shaped ends, and metal modelling tools which are similar. Another tool which can be used for modelling is a wooden handle with a loop of wire at each end; this is good for cutting away areas of clay for carving, and is often also used for turning pots on the wheel.

Hole Cutters

Another specialist tool. A hole cutter has a small handle holding what looks like a small metal tube with a slice cut out of the side. It is pushed into the clay and turned; when pulled out it cuts out a section of clay, leaving a hole, normally of about ½ in. (12 mm) in diameter.

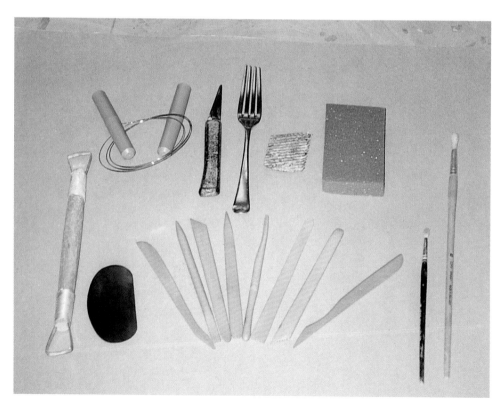

Kitchen Utensils

The kitchen has a wonderful array of tools that are cheap and easy to acquire. The knife drawer is a good place to start: ordinary knives are a reasonable substitute for a pottery knife for a lot of jobs, and a fork is always at hand in my own tool selection. One lives with my glaze brushes, as when I find that my small containers of glaze have dried out and gone hard, they mix up to a good consistency quicker if you scratch at and break down the dried up cake of glaze before adding the water. A fork pattern is good decoration, and cross-hatching is essential when joining slabs. Old potato mashers leave a pleasing pattern on the clay, as do other textured or patterned implements. Plastic bowls and old margarine cartons with lids make useful containers. Clingfilm is a good product to have at hand, as it stops the clay from sticking to the object it is moulded around.

Biscuit Tools

These are an aid I made up myself, for people who would like to create a pattern on their pot, but who did not have the skills to draw their own with confidence. I started with a slab of clay that had been rolled to about ½ in (12 mm) thick, then allowed to dry to leatherhard. Into this I drew the pattern I wanted, carving high and low areas to provide a textured relief. It would then leave an impression in soft clay. The carved slab was biscuit fired, leaving it hard enough to press into the clay, but absorbent enough not to stick. I also made numerals, so that the group could make house number plaques without having to struggle with getting the numbers looking neat. If you feel that you can-

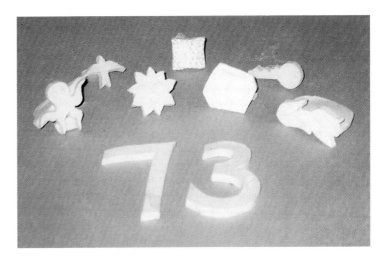

not draw well enough to make your own, it is very easy to trace the image that you want, and then to transfer the image to the clay, tracing over the pencil lines. I have made countless biscuit moulds for all sorts of occasions, and for people with very limited abilities. I have prepared a slab for them and provided a whole range of shapes and patterns – a sun, birds, trees, houses, sheep and many patterns made up to specific requests. Just by pressing the shapes into the clay, whole pictures can be built up. Some examples of themes we used were Christmas time, the farmyard, under the sea, etc. We also used random objects such as keys, to see what impressions they make. More adept members of the group, with good motor skills can help in the production of these textured slabs, helping to produce something for those less physically able to use.

Equipment

Clay Extruder

At the day centre I worked at I was lucky enough to inherit a clay extruder. There are many types; our particular one was called a *clay bulley*. A *wad box* is another common name for an extruder. What they all basically do is put clay under pressure, and as it has to escape somewhere, it is forced through the holes that have been cut in the base plate (the die). These holes can be cut in a variety of shapes, with a wide variety of uses. I often find these shapes continue to inspire me, and I have often been extruding coils for some-one's coil pot, and gone off on another tangent when the coils have been extruded in an exciting and unexpected shape. This always leads to great excitement among the group, and we start off on a new project. For example, the clay bulley that I used had been subject to some cruel treatment before it came into my caring possession and whenever I made coils with it, a wide sliver of clay would escape out of the side where it had been mistreated. These slivers were beautiful, and I would lay them in a large biscuit-fired bowl and slip them together, leaving natural gaps where the edges flowed in and out. The effect would appear a bit like rock strata, emphasised by the surface texture being roughed up as it was forced through the gap.

If you do not have any of this sort of equipment, a home-made one can be made with a silicon sealant gun that you use for baths or windows. You will need one of the empty canisters that held the silicon and you will have to cut the

nozzle off, leaving enough of a rim to hold a die of your own making. The die is the piece which goes on the end with a hole in, cut into a specific shape. The clay is forced through the hole creating a coil of the shape.

For the die you will need some very tough plastic, as there is tremendous pressure on this plate and they can snap. You can cut the plastic to a shape to suit your needs. A very good product that is used by people who do railway modelling and building, is called Plastikard, and made by Slaters of Matlock, Bath. This thick plastic sheet is very good to cut and ideal for making dies for your extruder, and it is the thicker gauge that you will need. You should not have much trouble acquiring this, as most modelling shops have a supply.

I have photographed the clay bulley that I used for years, and from which we made a large number of coil pots. It was great to be able to produce an abundance of lovely, even coils all ready for use, so allowing us to get on quicker with producing our designs, instead of being frustrated making all the coils by hand.

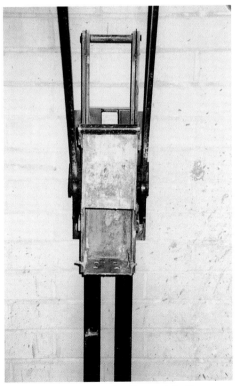

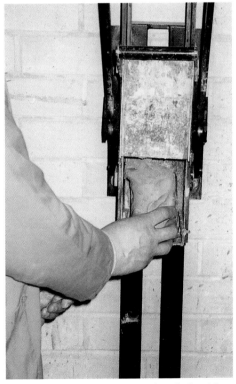

1. The empty clay bulley with flap up.

2.. The clay bulley being loaded with clay.

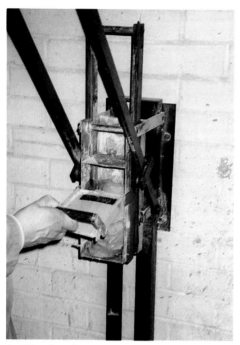

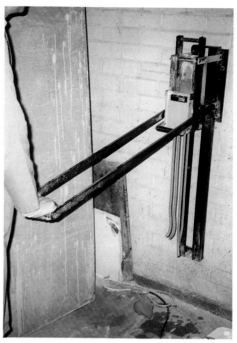

3. The flap being put down. The hooks are then locked into position underneath to hold the clay in.

4. The handle being pulled down, and the coils being forced out.

5. This shows how far off the floor you need your equipment to be mounted, to allow a good length of coil to be produced.

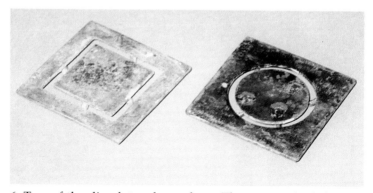

6. Two of the die plates shown here. The one on the left will give you a hollow square cross-section, the one on the right a hollow tube cross-section.

The Pugmill

In view of safety, it is very important to have a responsible adult use this machine.

The pugmill is a machine used for recycling soft clay. It is very helpful when a lot of clay is being used, especially when you use a lot of slabs and the offcuts pile up. There have been many occasions when, during a very busy class, I have pugged the waste clay to go straight through the slab roller, the slabs have been cut to shape and the scraps then recycled again. This situation often happens as well when extruding a lot of coils. I have often found that something which starts out with the intention of being therapeutic turns in to a production line, as the work goes home and orders come in from other members of the family. This type of encouragement seems to give the maker a hunger for production, and they become prolific. It gives people a great excitement and purpose. One extreme example is the garden mushrooms; the orders came in 20s, not just a few here and there, and we were told that they were being ordered for

2. The handle on the plunger has been pressed all the way down and the clay is being forced out of the end.

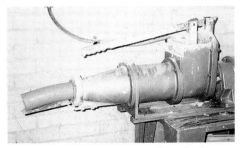

1. Lifting the plunger back and loading clay into the hopper.

3. Full view of the pugmill with the clay emerging.

people who lived as much as 70 miles away.

The pugmill is basically an extruder and can have die plates attached to it to produce coils or other shapes, but its main use is in recycling. It has a barrel, and to one end is a hopper where the clay is put in and a plunger used to push the clay down, through a safety grid, to a screw that is driven round by the motor on the end of the machine. This screw then carries the clay through the barrel, which decreases in size, compressing the clay until it comes out the other end ready for use.

The preparation of the clay for recycling is very important as you do not want to jam the machine — dismantling it is a long and laborious job. If you have really dry clay it will need to be soaked first to thoroughly soften the clay, but at this stage it will be too wet to go through the pugmill and will have to be spread out on a cloth and left to stiffen first. When it is about the consistency of stiff cottage cheese it can then be mixed with other soft clay, such as slab offcuts, and put through the pugmill. For the pugmill we had, the clay would be made in to balls about the same size as a tennis ball, going through the machine nicely. When you have your recycled clay, keep it in a plastic bin well covered up with polythene so that your clay will be perfect for use when needed. As long as it is well sealed, your clay will keep well.

The Slab Roller

A very important point is the safety of the roller in use; only a responsible adult should work this piece of equipment for if a finger should get trapped it would certainly be crushed.

In my work at the day centre I often used slabs to achieve a quick result and a neat effect. As you can see from a lot of the projects, you can use them in many different designs. You can make slabs by rolling out the clay with a rolling pin on cloth, using wooden slats to determine thickness. This is a good method for a group with plenty of time and energy, but very often you have people with very little strength, due to muscular dystrophy or other illnesses, or someone who has suffered a stroke and cannot apply sufficient pressure to the clay. This problem led to me rolling out a tremendous number of slabs before the class could start properly, and with no spare time between classes, it was taking place while everyone waited for my help. The solution to this problem was buying a slab roller, but the authorities I worked for did not have the spare money for this. I was lucky,

1. The clay is placed between the cloth, ready to roll; the handle is then turned and the clay is squashed between the two knurled rollers. They are tex-tured, so they grip the protec-tive cloth and pull it through.

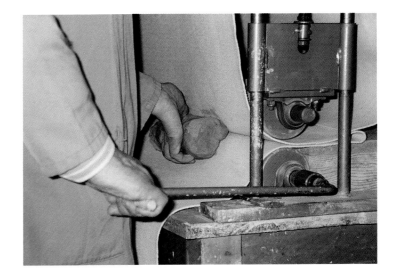

2. The cloth pulled back, showing the slab ready for use.

though, as our League of Friends agreed to buy us one from their funds. It has been invaluable ever since.

The roller we had could be adjusted for different thick-nesses of slab and we tended to use a ¼ in. (6 mm) thickness for most of our projects. It was a marvellous piece of equip-ment, being used not only for plantpots, dishes, model houses and lots of other designs, but also for the very fine slabs for the rose petal leaves in the rose bowls. The slab roller works in the same way as an old-fashioned mangle, squeezing the water out of washing, and many potters have made their own. If money is a problem, however, rolling out slabs by hand is still an effective option (if time-consuming). See p.42 for how to roll by hand.

The Potter's Wheel

In my years in this profession, the potter's wheel has given so much pleasure, from profoundly disabled people to highly trained people with a mental illness. People of every ability can enjoy having a go, but to get good results it does take a certain amount of time and practice. To become fluent at throwing you have to be fairly strong and have a reasonable degree of manual dexterity. However, the wheel is also useful for occupational therapy.

Everywhere I have worked there has usually been a potter's wheel of one type or another. Some have been kick wheels, where you drive the wheel round by kicking a treadle with your foot, or there has been an electric wheel where you control the speed as you do with an accelerator in a car. Both work well, you just have to get used to the feel of them.

During my work in the psychiatric hospital many classes had a high turnover of patients, and the potter's wheel was a great activity to break the ice. No one is a genius when they first have a go on it, and everyone thinks that they can do better than the next person. It was hilarious watching people itching to have a go whilst waiting their turn. With a little bit of practice and help centring the clay, quite good results can be achieved reasonably quickly.

At the other end of the scale I have found the wheel to be invaluable when working with profoundly disabled people with learning difficulties. There is always the difficulty of finding a variety of activities for them to do, and very often all they may be able to do is watch, or possibly only feel. With people who cannot see, hear or speak, it is rewarding to see them smile when you guide their hands on the revolving clay, and gently apply pressure on their hands to alter the shape of the clay, and feel the sides of the pot growing upwards in their hands. I do this with those people who cannot control their hands, and their pleasure is immense when I have taken control of their movements, enabling them to enjoy the physical feel of throwing, as well as seeing the pot being made with their own hands. This basic approach can be used in a great variety of creative projects.

For throwing, the clay needs to be fairly soft and it needs to be wedged so that the texture is even throughout the clay. Any harder patches in the clay will disrupt the throwing process and throw the pot off centre, as your fingers will catch on it as it revolves. Good preparation for throwing will increase your chances of success, so get a few balls of

clay ready so that you do not waste time getting on and off the wheel and cleaning your hands up every time you need another ball of clay. You will need a bowl of water, a small sponge — I feel comfortable with one about 3 x 5 x 1 ½ in. (8 x 12 x 4 cm); and a wire to cut the pot off the wheel.

1. The clay needs to be patted into a round ball, as this will make it easier to centre. A ball of clay weighing about 14 oz (400g) is a good size to start with.

2. The ball of clay should look like this, with no large flat areas or bumps.

3. The clay then needs throwing quite hard onto the centre of the wheel. It needs to stick securely, as it can fly off the wheelhead when the water is added.

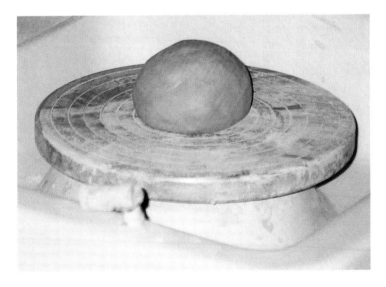

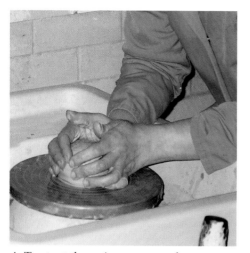

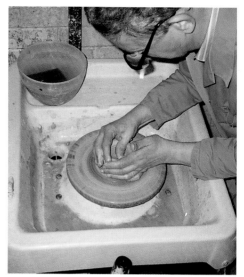

4. To start throwing you need wet hands so there is no feeling of friction when you press on to the clay. It helps to give you more control if you rest your forearms on the edge of the wheel tray, as shown in the photo.

5. After you have got the clay running smoothly, with no wobbles, you can start to press in to the centre to make a depression. Do this by keeping your right hand steady on the clay, and slowly press your thumb into the centre. Meanwhile keep your left hand on the clay to keep it steady.

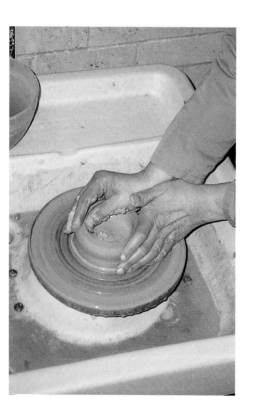

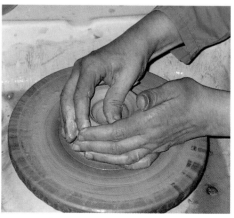

6. & 7. also show this stage.

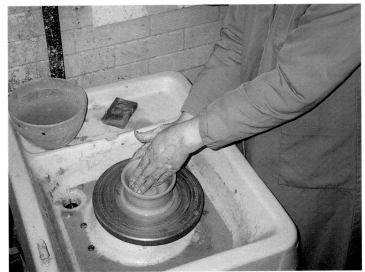

8. Remember to keep your hands lubricated with the water, and now start to press your hands further towards the base of the pot, leaving the base about ¾ in. (2 cm) thick. At this stage you can start pulling up the sides of the pot, with your fingers gently squeezing the clay from the inside and the outside, forcing the clay upwards. This usually takes practice as the centrifugal force of the spinning wheel tends to make the pot go outwards into a dish shape, explaining why learners seem to throw a lot of ashtrays. The way I deal with this myself is to keep my right elbow tucked well into my waist and concentrate on keeping my right hand moving vertically upwards, whilst leaning over the pot and looking directly down on it, so as to check that it does not go outwards.

9. When you are happy with the pot, hold your cutting wire taught and cut right under the pot, keeping the wire flat on the wheelhead. A little extra water on the wheelhead, around the pot, will help free it from the wheel.

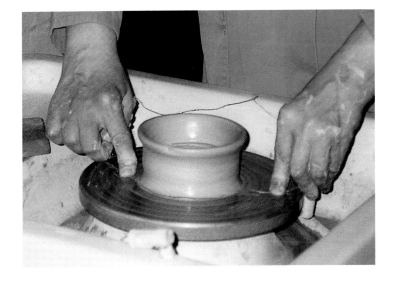

10. 11. & 12. With your fingers at the base of the pot, gently slide it towards your other hand to place it on a board to dry. If it does not slide very easily, repeat the water and the cutting and try not to touch the rim, as it distorts very easily at this stage.

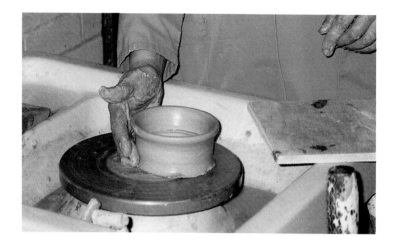

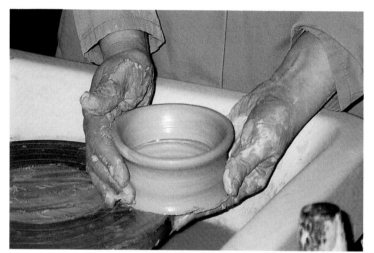

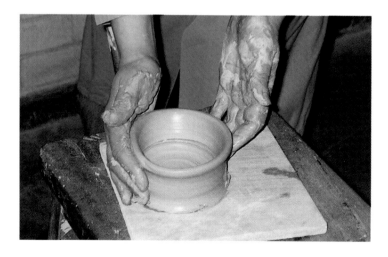

3. Packing and Firing Kilns

Although there are a lot of different models and makes of kilns about, the basic firing techniques are similar. The principle is to fire the pot to a high enough temperature for it to turn into pottery.

Packing the Kiln

Before packing, make sure all the work is bone dry, otherwise it may explode. A helpful thing to do is to divide all the work into groups of similar height, so each group can go on the same shelf. When placing pots in the kiln for their *first firing* they can touch or be stacked on top of each other if not too delicate. It is sometimes easier to put the shelf props in the kiln in their positions first, and then place work around them. Make sure the work is not taller than the props. When the shelf is full, another kiln shelf can be put

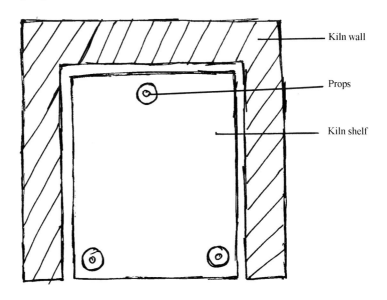

Looking down into the kiln, the bottom shelf is shown with the positions of the props.

Kiln wall

Props

Kiln shelf

in for some more work. Packing kilns will vary depending on the shape of the kiln and its shelves. It is safest to place the shelf on three props rather than four (if possible), as this is the most stable number. If you are putting in more than one level of shelves, try to place the props in the same position as the ones below. This will help prevent the shelves from warping, especially at the higher stoneware temperatures. It is also sensible to put the heaviest pieces of work at the bottom of the kiln. While packing, try to be careful not to knock the thermocouple, which is a sort of kiln thermometer, as it is in a ceramic sheath and can easily be broken. They are very expensive to replace! My diagram will show more clearly how to pack your kiln.

Once the kiln is packed, shut the door and lock it. It is important that nobody tries to open the door while it is firing, as the extreme heat is very dangerous, and also all the work will crack. Make sure the bung hole is open (usually a square hole on the top of the kiln). There should be a kiln brick or old kiln shelf which can be used to cover it later. A house brick can be used, but may crack in the firing, so make sure it can't fall in. There should also be a spyhole at the front of the kiln. Make sure this is open too. It will also have a brick or bung to fit it, and this will be needed later.

A photograph of the electric kiln I used while at the day centre, showing the various heights and type of ware we made, with tall slab-built vases at the back and noughts-and-crosses boards at the front.

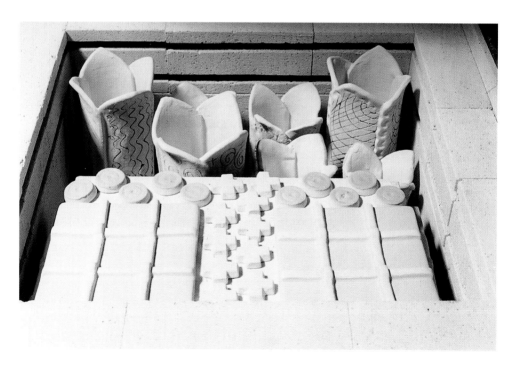

A cross-section of a kiln packed for a biscuit firing. Note how bowls or cups may be stacked to save space and energy.

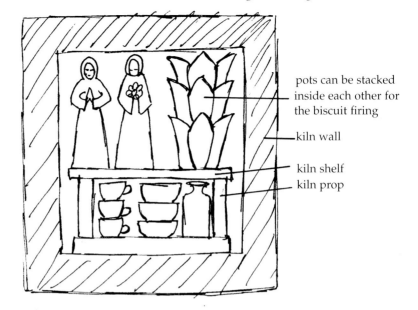

pots can be stacked inside each other for the biscuit firing

kiln wall

kiln shelf

kiln prop

The first (biscuit) firing

The first firing must be done at a slow, steady rate so that any moisture left in the pot will not turn to steam and explode the pot. If your kiln is an electric kiln with an automatic firing programmer, now is the time to set it (see below for suggested firing temperatures). Remember to set the cut-off temperature. The firing will take most of the day if you are firing slowly. If your kiln is a manual kiln (electric or gas), you will need to check it every hour to make sure the temperature is still climbing. You should gradually turn up the temperature throughout the day. Do not put the kiln on full power until it has reached 600°C (1112°F). Towards the end of the firing you should check the kiln every 10 minutes, to check it doesn't over-fire.

For the first firing (the biscuit or bisque firing) the kiln should heat up at a slower rate than 100°C (212°F) per hour. A safe temperature is about 50 or 60°C (122 or 140°F) an hour, until the kiln reaches red heat at 600°C (1112°F). The bung or spyhole is left open until 200°C (392°F) to let the excess moisture out of the kiln; the bung or spyhole can now be closed to conserve heat.

The rate of increase after 600° (1112°F) is reached can be faster (perhaps 100°C / 212°F an hour), until you reach the final temperature of 1000°C (1832°F). On most kilns there will be a temperature gauge so you can see how the firing is going. This is connected by wire to an instrument called a thermocouple, which goes in through the kiln wall to the kiln chamber, where it reads the temperature. If your kiln is

A cross-section of a kiln packed for a glaze firing, showing how the props are positioned in the kiln for greatest stability. Three is usually better than four supports for stability.

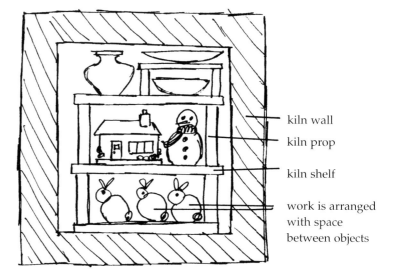

kiln wall

kiln prop

kiln shelf

work is arranged with space between objects

manual, do not forget the kiln, and go home leaving it on! Write a note, or set an alarm clock or kitchen timer to remind yourself if necessary!

The second (glaze) firing

For the glaze firing the rate of increase can be a little quicker, about 100°C (212°F) an hour, as you will see on the graph. At about 600°C (1112°F) the rate can be increased to 150°C (302°F) an hour. The bung or spy hole should also be left open on the glaze firing until about 200°C (392°F). The second firing of your pots will usually be a glaze firing, where

View down on a top loading kiln. Work is placed on each shelf with space between objects, to prevent them from sticking to each other or the kiln wall.

A kiln packed for a stoneware glaze firing, where the pot sits directly on the shelf. The glaze on each pot is well clear of the shelf, and there is space around the ware so it cannot stick together in the kiln when the glaze becomes molten.

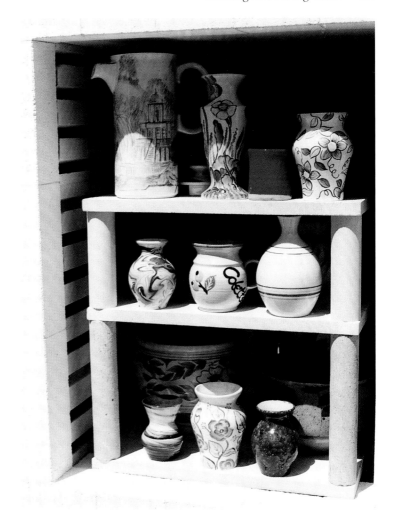

it is important not to have the pots touching, as the melting glaze will stick the pots together. In all glaze firings, the glaze must be cleaned thoroughly off the base and at least ¼ in. up the side of the piece of work (use a damp sponge to do this). Stoneware glazes are usually fired to between 1200° to 1300°C (2192° to 2372°F). If preferred, with lower-firing glazes such as earthenware, pieces may be glazed all over before being placed on three small ceramic supports called stilts, spurs or saddles. These are carefully removed after firing, when the pot is cool, and any sharp edges are ground down. Earthenware glazes are normally fired to 1000°–1100°C (1832°–2012°F).

Switching off the kiln at the correct time is also important for the glaze. If your kiln has an automatic firing

programme, it is important to be sure you have set the kiln cut-off correctly. If you are unsure, contact the supplier or manufacturer. If your kiln does not have an automatic cut-off, it is important to check the kiln every hour, and at the end of the firing to check it every 10 minutes to ensure you reach the correct temperature. Over-firing by 10°C (50°F) will probably not matter too much, but overfiring by 50°C (122°F) or 100°C (212°F) will result in the glaze melting off the pots and on to the shelves, and at stoneware temperatures may end up damaging the kiln!

The firing process

The majority of kilns available will be heated by electricity, mains or bottled gas. These vary in their firing instructions, so individual instructions will need to be followed. If you have not got any instructions there is usually a metal plate on the kiln where the name of the manufacturer will be, and if you contact them they are usually helpful in providing operation information (see also the suppliers list on p.126).

Key points to remember about firing

First firing (biscuit firing) 1000°C
In two stages
• 50°C (122°F) an hour until 600°C (1112°F)
• 100°C (212°F) an hour until 1000°C (1832°F)

Second firing (glaze firing)
• Earthenware at 1000°C (1832°F) (exact temp. depends on glaze)
• Stoneware at 1200–1300°C (2192–2372°F), exact temp. depends on glaze
In two stages
• 100°C (212°F) an hour until 600°C (1112°F)

• 150°C (302°F) an hour until top temperature

Kiln shelves
Where possible, use 3 props rather than 4 to support your shelf as this will ensure stability. Put the props in the same position as the shelf below for every level you put in. This will reduce shelf warping especially at stoneware temperatures.

Kiln switch off
Remember to set the automatic cut-off on the kiln programmer! If the kiln does not have one then remember not to go home at the end of the day leaving the kiln on! It is important to check the kiln every hour, and every 5–10 minutes right at the end of the firing, so that you can switch it off at the correct temperature. Leave yourself a note on your coat, or set an alarm clock or kitchen timer to remind yourself.

Opposite
Graph 1 shows the first (biscuit or bisque) firing, which is slow. To be safe it should be no more than 100°C (212°F) per hour to allow the water that is trapped in the pot to escape gradually without damaging the work.

Graph 2 is of an average stoneware glaze firing where there can be a faster rise of temperature in the early stages as the work in the firing has already been fired in a biscuit firing. It is important not to put un-fired work into a kiln full of glazed work. If the unfired work explodes due to the faster rate of firing, it will damage the glazed work by sticking to the glaze. It could also damage the shelves and elements of the kiln by sticking to them.

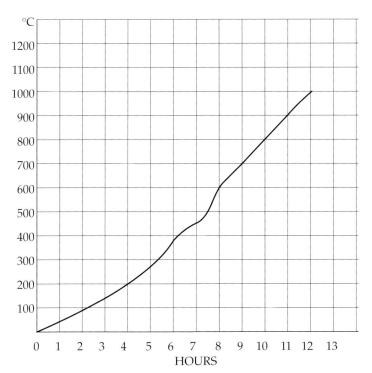

Graph 1.
Firing graph for
a biscuit firing.

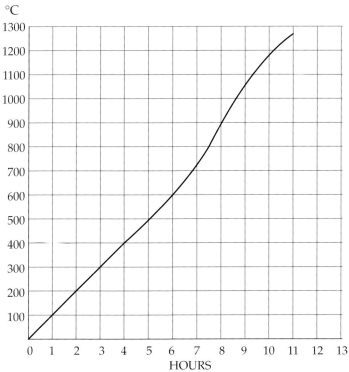

Graph 2.
Firing graph for
a stoneware
glaze firing.

Alternative Kilns

These are kilns that are not produced by a manufacturer such as the electric, natural gas or propane gas kilns that you can buy. Instead they are handmade, often constructed out of everyday items, and sometimes only lasting one firing. I am adding this section on alternative kilns for the reason that a lot of people who want to make pottery objects do not have access to a kiln. These kilns give a very different finish to the work compared to manufactured kilns. They do not get up to the same temperatures either, so the work will not be water tight, instead it will be purely decorative, and can have a lovely appearance, as these kilns can create some special effects.

The alternative kilns covered here are paper kilns, sawdust kilns, and pit firings. The bonus about these various kilns is that they use cheap or free fuel. The drawback is that it is very hard to control the temperature at which the kiln rises. This is a problem because if the temperature rises too suddenly, water trapped in the clay particles (even if it appears bone dry) will try to escape as steam and will cause an explosion in the work. If the work can warm up gradually, the water simply evaporates off slowly. The method I have developed to avoid this problem is to warm up the pots in a domestic oven beforehand. It is important that the kiln is ready to start as soon as the pots are out of the oven, otherwise they will cool down too much to make it worthwhile. Although it is important to try and maximise the success rates of such projects — less so for yourself than for those you are working with — it is important to accept that problems will arise, and not to blame yourself when they do.

With all of these types of firing the pots are too porous to hold water and very often they have a matt surface. With some of my students work, we painted on a coat of acrylic varnish, which gives a nice sheen, brings out the colours, and makes them easy to clean.

• It is **very important** with all firings to have a responsible person in charge, and to be aware of any fire hazards, such as flammable materials that may catch fire from sparks. Always try to fire in a clear open area, and keep a fire extinguisher or several buckets of water on hand just in case something goes wrong.

My first paper kiln construction

My first experience of a paper kiln came about when I went to work at another day centre for two weeks. The students and staff were very helpful and enthusiastic that I was willing to teach pottery to give the students something new to try. I had planned to take the pots back to my day centre to fire them but nobody wanted to wait that long. There was nothing I could make a sawdust kiln from, and it was too dangerous to leave a pit fire smouldering overnight. I had seen an article on paper firing in a previous Ceramic Review, so we decided to try it.

This caused great excitement as everyone brought in their old newspapers, and everyone set to work, some rolling tubes, others weaving them together. We decided to fire our least favourite pots first, and a good job we did. When the kiln was ready, we all stood around expectantly, and lit the base. The kiln started burning, but it was too fast for the pots, and as the temperature shot up we started hearing dull thuds and bangs as the pots inside exploded.

Eventually I worked out a solution. We couldn't slow the flames down but we could heat the pots up, so that most of the water inside them had evaporated before they ever reached the kiln. It is the water trying to escape too quickly which causes the breakages. We did the firing again, packing the kiln with hot pots, and happily proving the project a success.

The teamwork of the whole experience was wonderful, and eventually with my help the centre found funds for a kiln and continued to produce pottery work, which they then sold at their coffee mornings and fêtes.

Warming the pots before firing

1. Put them on a baking tray if you have one (for ease of manoeuvring into the oven, and carrying to the kiln), and place them in the domestic oven. Close the door, and turn the oven onto the lowest setting, for example 50°C (122°F) or mark 1 for half an hour.
2. After half an hour turn the temperature up to 100°C (212°F) or mark 2.
3. After half an hour turn the temperature up to 150°C (302°F) or mark 4.
4. After half an hour turn the temperature up to 200°C (392°F) or mark 6.
5. After half an hour turn the temperature up to 250°C (482°F) or mark 8 or 9.

After two and a half hours in the oven the work will be very hot. Carefully transfer the work to the kiln using very thick oven mittens (or proper kiln gloves, from suppliers), and start firing as soon as possible. If they cool down too much they will re-absorb moisture from the air, and still have problems in firing.

Paper Kiln

The teamwork of the whole experience of building and firing our kiln was wonderful, as was the pooling of resources and the help with rolling up and constructing the kilns. This can be as rewarding for some as the resulting fired pieces. If you have time and resources to do several of these kilns, you can start by firing the least favourite pots first, until you feel confident with the process.

It is **very important** that a responsible person stays with the kiln at all times.

You will need
- stack of newspapers (at least 1m/1 yd 3½ in. tall)
- matches
- access to a domestic oven
- oven gloves
- plenty of towels or tea towels
- baking trays
- access to an outside space (with room for large bonfire)

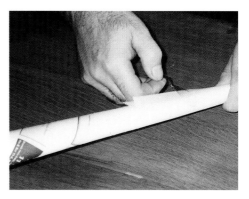

2. Take four full pages of newspaper and starting from the corner roll them up diagonally into a tube approximately 1in. (3cm) in diameter. The next step is to flatten the tube. You can prepare a huge pile of these in advance, or do it as you go. If there is a group of helpers, a couple of people can be set to do this task in advance.

1. The amount of papers you will need depends on the size of kiln you want to build, and how many pots you have to fire. After you have done a couple of these you will know roughly how much to use. Dimensions of the kiln I built are given below.

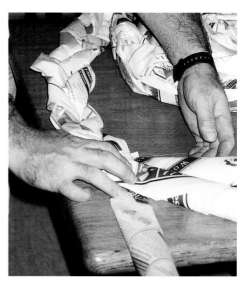

3. Make the base of the kiln by interweaving the flattened tubes into a flat base similar to a rush mat. This will need to be three layers thick at least. The base of our kiln was 14 in. (35cm) thick (approx. four layers).

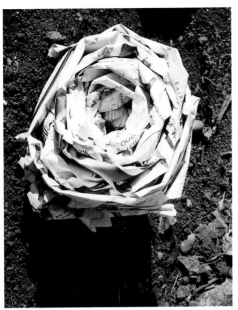

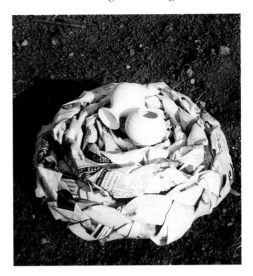

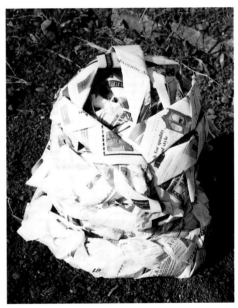

4. The same technique is used for the top of the kiln, except the tubes should be woven into a beehive shape. The top should be woven as a separate piece, to be put on at the end. It should be about 14in. (35cm) thick as well, (approx. four layers). The more paper you can use the better as this type of kiln burns down very fast, and the longer it burns the more chance there is of reaching red heat. Red heat temperature is reached when you can see a red glow from inside the kiln, and it is the stage when the clay chemically turns into pottery. After this it will not break down into clay again if placed in water.

5. Place the base of the kiln in a clear area outside, away from anything likely to catch fire. It is much easier to do on a dry day, and on a dry concrete surface. Have the top of the kiln and the matches nearby.

6. Now you can bring the very hot pots out of the oven, wearing your oven gloves wrap them in tea towels or similar to keep them warm while you carry them to the kiln. Place the hot pots directly on to the base of the kiln (unwrapping the tea towels first!). When they are all placed, put the top of the kiln over the pots, and make sure it is sitting well onto the base.

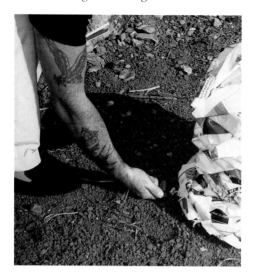

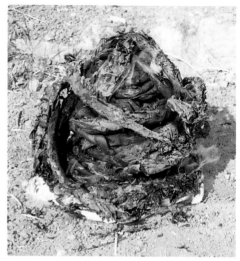

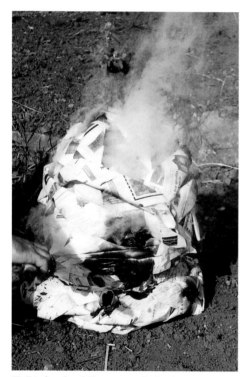

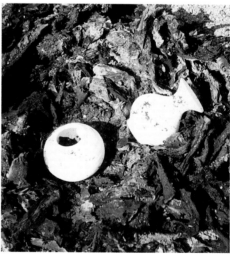

7. Light the kiln around the base at about five intervals so that the kiln will burn evenly all the way round, and then stand back and watch, until all the paper has completely burnt away.

8. The pots will then need time to cool down before they are safe to handle. Remember to put on your oven gloves before carrying them inside!

Sawdust Kiln

Another way to get your pots fired without a kiln is to fire them in sawdust. Sawdust firing can produce a beautiful range of effects, and potters often put ready-fired biscuit ware into a sawdust firing for the final effect. It is not usually used for glaze firing. There are a few ways you can go about it — one is to use an old metal dustbin with a few holes punched in the side; the holes are needed to allow some air flow for the sawdust to burn.

Alternatively you can build the equivalent out of house bricks, leaving a few gaps for air holes in the walls. If you have enough sawdust and time, you can do a few firings, which means that the more fragile work could be fired separately.

Read the section on warming pots on p.35, as this is an important part of the process, which will help to ensure the survival of your pots in the kiln!

It is **very important** that a responsible person stays with the kiln while it is burning down and checks on it. As it will have to be left smouldering over night, it is important that it is located away from anything that might catch fire from floating sparks, and away from any curious children.

Read the section on warming the pots in the oven, and allow 2½ hours for them to warm. Meanwhile, you can prepare the kiln.

You will need
- an old metal dustbin or house bricks
- metal lid or sheet of metal to cover bin
- two or three black bin liners (or equivalent) of sawdust
- matches
- large tongs to lift out the pots with
- access to a domestic oven
- oven gloves (to carry hot pots)
- plenty of old towels or tea cloths
- baking tray

1. Your old dustbin will need to have air holes punched into the sides of it, which should be about 1–2in. (2.5–5 cm) wide. This will allow air to be drawn in during firing. Too much air means the temperature will rise very sharply and the pots will crack.

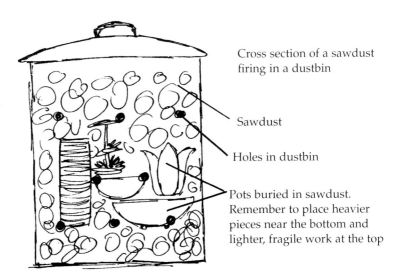

Cross section of a sawdust firing in a dustbin

Sawdust

Holes in dustbin

Pots buried in sawdust. Remember to place heavier pieces near the bottom and lighter, fragile work at the top

2. Place a good layer of sawdust in the base of the kiln about 6in. (15cm) deep.

3. Now remove the warmed pots from the oven, remember to put on your oven gloves to protect your hands, and wrap the pots in tea towels while you carry them to the kiln, in order to retain their heat. This will help prevent the pots from breaking in the kiln.

4. While packing the kiln, put the heavier work at the bottom and the more fragile work on top. Put a generous amount of sawdust around each pot and between each layer. As the sawdust burns away, the pots will settle down on each other, and fragile work at the bottom of the pile may not survive.

5. When all the work is packed, put a final thick layer of sawdust on top before you light the top of the sawdust and put the metal lid on the kiln. Watch to make sure it is going (it will appear as a steady smoulder). You can also light the sawdust lower down by pushing lighted sticks through the holes. This may take a few attempts.

6. Stay with the kiln for half an hour or so to see that it is still smouldering and check it regularly afterwards. You will then have to leave it overnight until it has burnt all the way through, and you can unpack it after it has cooled down enough.

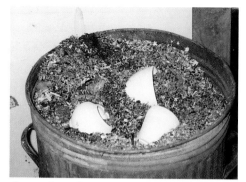

A sawdust firing in a metal dustbin showing how the pots are arranged.

The type of construction you would use in a brick-built sawdust kiln.

If you are using bricks you will need to build a square or circular chamber by simply placing bricks on top of each other (try to alternate them on each layer). The base can be bricks or soil, as long as it is something that won't burn. Place the bricks close together leaving some gaps, but none too big.

Pit Firing

You will need
- Access to a domestic oven
- oven gloves
- old tea towel
- baking tray
- sawdust
- branches
- bits of wood
- matches
- a spade
- 2/3 metal sheets (such as corrugated iron)

Although this is a basic way to harden your pots, it has been used for thousands of years, and a lot of studio potters now use it for the beautiful and random patterns and colours it produces. It will help if the ground is not too wet, as this may dampen the flames. Some potters put dry seaweed next to or around their pots which burns leaving a distinctive pattern on the pot's surface.

Before you start, read the section on warming your pots in the oven on p.35, and allow 2½ hours for them to warm. This will give your work a greater chance of survival. If it is not possible, be prepared for a few breakages.

1. Find a safe place to dig your pit. The size will depend on the amount of work you want to fire at one time, but it is best to start small, and not to fire everything until you know the process. A size of about 2 ft (60cm) square will allow for about five small pots and plenty of fuel.

2. Have all your branches and wood stacked nearby. Put a 6in. (15cm) layer of sawdust or small sticks in the base of the pit.

3. Now bring your pots from the oven, wearing your oven gloves to protect your hands, and wrapping the pots in tea towels while they are carried from oven to kiln. Place your pots onto the small sticks or sawdust.

4. Cover the work with plenty of wood, starting with smaller twigs and sticks and working upwards towards the larger bits of wood, like a bonfire. Try not to come above the level of the ground. You can put in a few bits of paper near the base to help light it.

5. Light the base in several places, check to see it is going, and then cover it with a couple of sheets of metal. Corrugated iron is good because it still allows a small amount of air into the pit to help combustion.

6. Leave to burn through (best to leave it until the next day), and when it is cool enough, you can unpack. Remember to wear your oven gloves when you carry the pots away as they may still be hot.

4. Projects

General introduction

These projects have been designed to give a broad range of activities for people to try. However, some of the projects such as the Garden Mushrooms or the Cabbage Dish will be suitable for all abilities whereas others, such as the Seven Dwarves in the modelling section, are more challenging and require more manual dexterity. Please read the introduction to each project for information.

Generally, each project will involve one or more basic technique. These are described below, but each project will have instructions specific to it (such as sizes or quantities etc.).

Basic Techniques

How to make/roll a slab
Find a clear patch of table, and put down some newspaper, or a piece of old cloth (such as an old table cloth). If you have wooden slats, these will help enormously. About $\frac{1}{2}$ in. ($1\frac{1}{2}$ cm) thick is a good size to use. Lay these on the paper or cloth with a good space between them. You can now roll out your slab of clay between the slats, making sure the rolling pin stays on top of the wooden slats. This means that your slab will roll out to an even thickness all over, the same thickness as the slats. As you roll out your slab it will help to keep turning it over and around so that you are rolling in different directions. If you are using newspaper, you will need to keep changing it as it will become taught and then soggy very quickly. (See also photo on p.58.)

How to make coils
Take a lump of clay, and shape it roughly into a sausage

shape with your hands. Now start to roll your sausage on a clean surface. A slightly absorbent surface is easier than plastic to roll on. The key with rolling coils is a very light touch, and try to move your hands along the coil, so you are not always touching the clay at the same points.

How to model
Modelling varies depending on the size and the shape of the thing you want to make or model. The basic principle is to take a lump of clay slightly larger than the required size, and shape it roughly into the shape you need with your hands. Then scoop out some of the excess clay from underneath (leaving an inch thickness to work with). Then gradually, using modelling tools or anything useful, start to shape the clay, carving bits out or adding bits of clay on as needed, until your piece takes shape. (This is covered more thoroughly within the relevant projects).

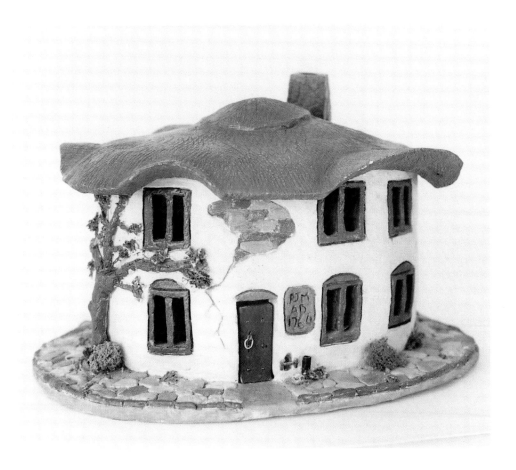

Project 1 • Garden Mushrooms

You will need
- knife/cutting tool
- slip
- brush
- cloth, rolling pin, wooden slats
- plaster mould or dish

This project is suitable for all abilities, with more or less help. Techniques used are slab rolling, making coils and pinching edges. These mushrooms, when fired to stoneware, are completely weather- and frostproof, and so they make an ideal garden ornament, especially during the winter months.

This project lends itself to being roughly made, as the cracks and imperfections in the clay help it look more realistic. When placed in a concealed or sympathetic position, the clay piece has often been mistaken for the real thing.

1a. Roll out a slab of clay (see p.42 for instructions).

1b. Prepare to place the slab into a mould. For the mould I use a biscuit-fired dish as it is absorbent and does not stick to the clay. First line any dish shape you think may be useful, e.g. cereal bowl, soup bowl, etc., with either a paper towel or a piece of plastic, to stop the clay sticking to the dish.

2. Gently ease the slab into the bowl, as you would a pie dish with pastry.

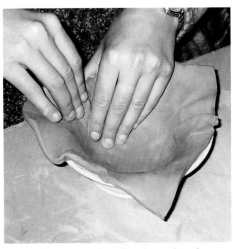

3. Gently press the clay into the shape of dish.

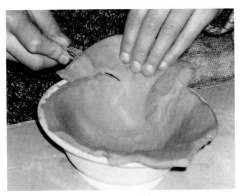

4. Cut the excess clay off.

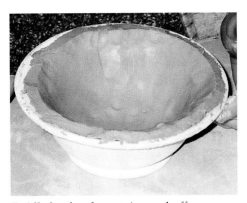

5. All clay has been trimmed off.

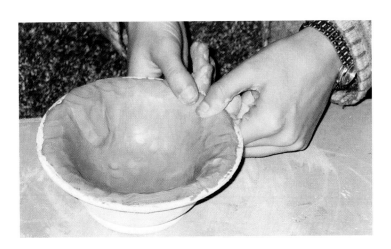

6. Press on cut edge of clay to give a softer more natural look; the unevenness of pressing helps achieve this.

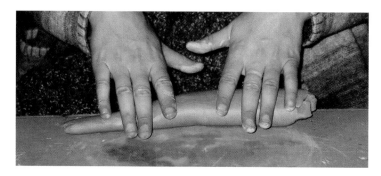

7. Start rolling a piece of clay to make the stalk. The clay should be carrot-shaped; fatter at one end.

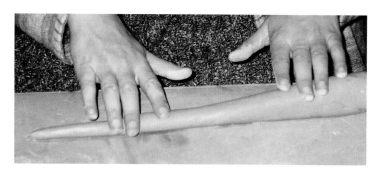

8. Roll harder on one end to produce a taper. This needs to be about 10 in. (25 cm) long, and the thicker end needs to be about 1¼ in. (3 cm) wide.

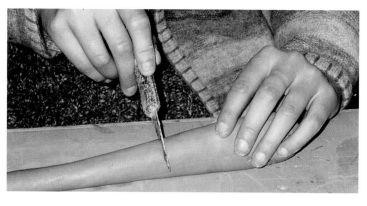

9. Cut the stalk to size, to suit the head of the mushroom.

10. Score the inside of the mushroom lightly with a knife, and apply a thick layer of slip.

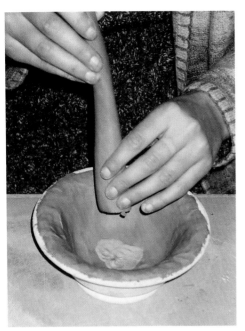

11. Place thick end of stalk onto the slip.

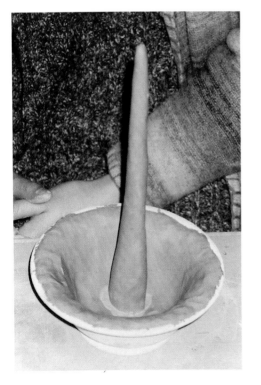

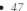

12. Ensure the stalk is well stuck by pressing down firmly.

13. As the stalk often falls over, make sure it is standing vertically before you leave it to dry.

Leave it to dry thoroughly before biscuit firing to approximately 1000°C (1832°F).

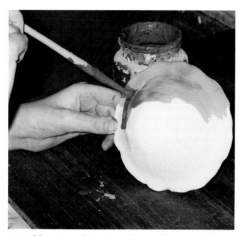

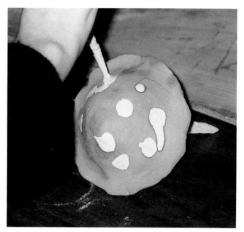

14. Glazing. Stir the glaze thoroughly then paint evenly on to the top of the mushroom. This is the only area that needs glazing.

15. Spots of different coloured glazes can be added, or any design applied. The mushroom is fired in the position you see here, so it is important to thoroughly clean the glaze away from the outer rim, (where the mushroom touches the shelf) by at least 10 mm (½ in.), to prevent the extra layers of glaze running and sticking to the kiln shelf.

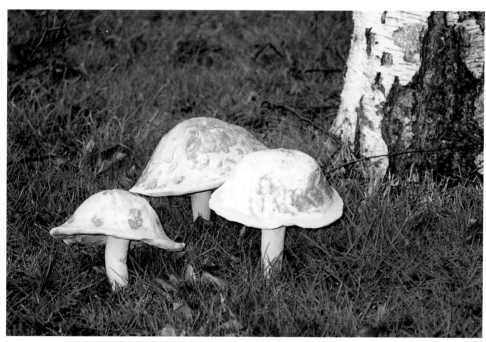

16. The finished mushrooms in situ.

Project 2 • A Tortoise

You will need
• dish (mould
for tortoise shell)
• tissue paper
• slip
• brush
• knife/cutting
tool
• pointed model-
ling tool

This project suits all abilities, you will need to be able to roll small balls of clay and make small sausages.

These have had great success, and we have sold a lot through our fêtes and coffee mornings. You will need a dish to use as a mould for the outer shell of the tortoise. Try and find one with a pleasing shape. I use a biscuit-fired pot that is absorbent and will allow the clay to be released from the mould with ease. If you use a glazed pottery or plastic dish, first line it with tissue paper or fine cloth so that when ready it will come out of the dish with ease.

1. Roll balls of soft clay that are about ¾ in. (2 cm) to 1 ½ in. (4 cm) wide, or look like large maltesers.

2. Place them one by one in your dish, lying them side by side until they come up to the rim.

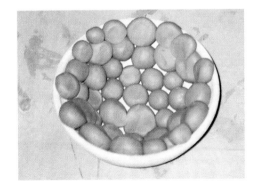

3. The fully lined dish with the balls of clay just protruding over the side, leaving a good edge for the bottom of the shell.

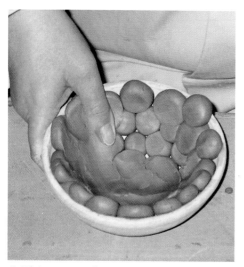

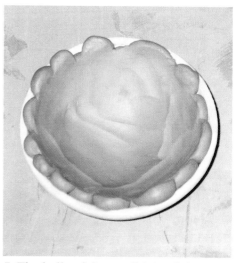

4. This stage takes quite a bit of care, as you need to join the balls of clay by smoothing them together. It is important to push them together well, as when the tortoise dries out, it can fall apart at these joins.

5. The balls of clay well joined, leaving the edges still rounded off.

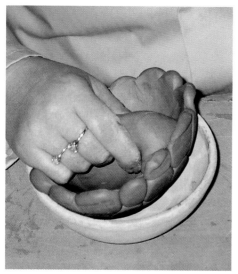

7. Once you are satisfied with the shell, and have discovered the pattern made by the balls of clay, place it back in its mould to support the sides, while you stick the legs on. The legs are made from slightly larger balls of clay than those used for the shell, and they are rolled slightly longer. Apply slip to each leg before joining.

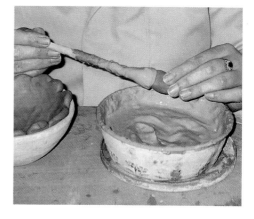

6. You now need to check that the shell will come out of the dish. Take a handful of soft clay and press it into the shell, before using it as a handle to pull the shell out. This may take a little practice.

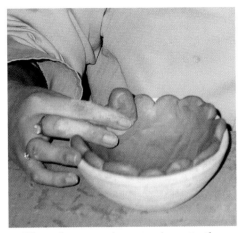

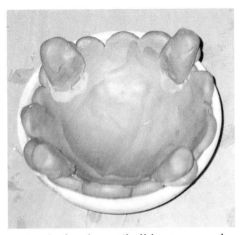

8. These legs are then stuck on to the sides of the shell with slip.

9. Apply firmly until all legs are stuck in place.

10. Take the shell out of the mould as in step 6 and stand it on its legs.

11. Now make a head, using roughly twice as much clay as needed for one of the malteser-shaped balls. You may shape this how you want, like old dinosaurs and reptiles, but we do usually have a long rounded shape. A lot of modelling and detail is lovely, but I often find a simple approach is easier for a lot of people, so a pointed tool is used to make the eyes (a cheap alternative would be a pencil).

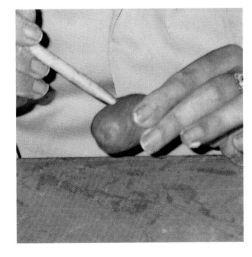

12. A knife blade pushed horizontally into the front of the head makes a mouth, which can be opened up a little by prising the two lips slightly apart.

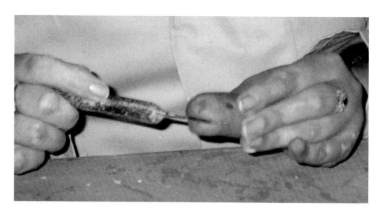

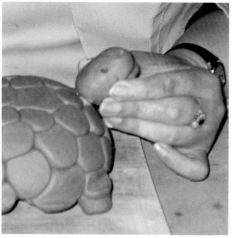

13. The head is stuck on with slip, in the same way as the legs.

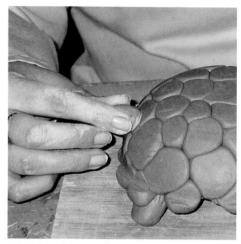

14. Model a small pointed piece of clay for the tail and add this on with some slip.

15. All modelling is now complete. Once it is completely dry it can be biscuit fired (see p.27 for firing instructions).

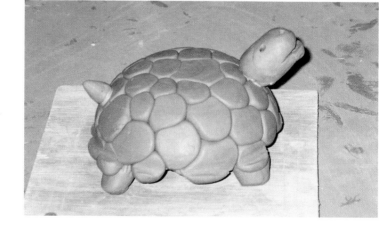

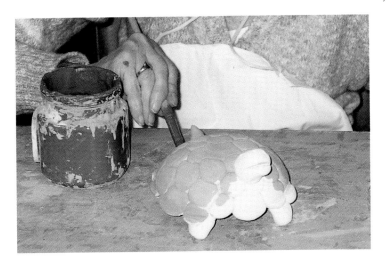

16. The tortoise here has been biscuit fired and we are painting it here with a soft brown glaze. Sometimes we add a blob of white glaze to the centre of the patterns; this melts into the brown glaze, giving a realistic graduated look. The feet need to be completely wiped clear of glaze before the glaze firing takes place.

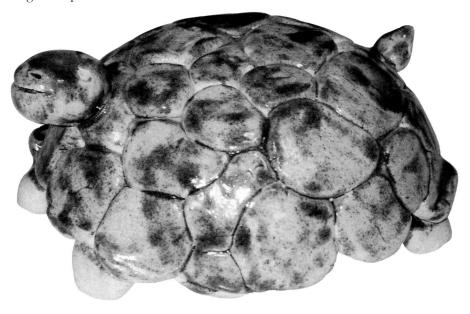

17. The finished tortoise. We have also made larger tortoises in things such as mixing bowls; these can be used as garden seats for children, as fired to stoneware they are completely frost- and weatherproof.

Project 3 • A Cabbage Dish

You will need
- tissue paper
- cabbage leaves
- cloth, rolling pin and wooden slats
- knife/cutting tool
- bowl (to use as mould)

This project suits all capabilities, you will need to roll slabs and be able to pinch the edges of the clay. Help will be needed to trim the thickness down on the cabbage stalk.

For this dish we used fresh cabbage leaves, and for other projects you can use a wide variety of other foliage available. I have found large maple leaves, rhubarb leaves and conifers particularly successful. Be aware of the depth of the slab of clay that you are going to use, and the depth of the veins on the leaves — if they dig in to the clay very deeply your pot will have a weak spot in this area.

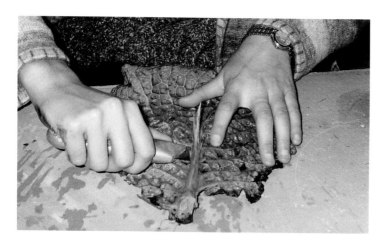

1. The thick main stem on your cabbage leaf can be cut down. Be very careful to cut away from you for safety.

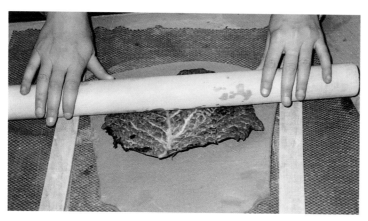

2. Roll out a slab as shown (see p.42 for fuller instructions). Place the leaf on the slab so that the side with the most texture is in contact with the surface of the clay.

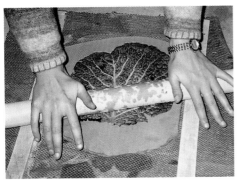

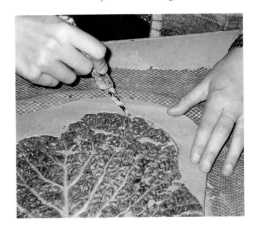

3. Roll your cabbage leaf on to the clay and press down well to ensure the leaf has stuck to the clay and left a good imprint.

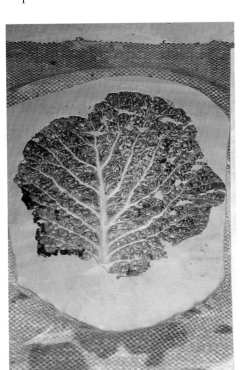

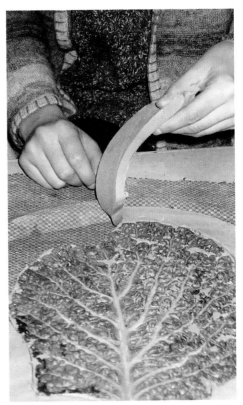

4. With the leaf well flattened on to the clay, check that there are not edges curling away from the surface.

5. Cut round the edge of the leaf, being careful not to leave any bits of leaf in the excess clay trimmings as these will rot down in the recycled clay.

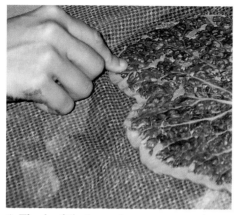

6. The leaf that you have cut round now has a hard looking edge to it, so to make it look softer and more natural you can just press your finger or thumb along the edge to give a nice undulating finish.

7. The leaf is now ready to be taken off the slab. Carefully peel back the leaf, and the image and texture of the veins will be left behind in reverse. The leaf may break up and small bits may stick to the slab; these can be left to burn away in the firing.

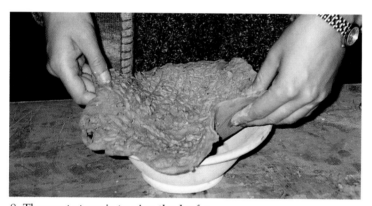

8. The next stage is to give the leaf a dish shape. It can be left to dry in a variety of different dishes, but if the dish is not porous, remember to line it with some fine cloth, or a paper towel or tissue, so that the leaf will release easily from the dish when it dries.

9. For the final touches the edges can be pinched more or curled in or out-wards, in whatever shape you fancy.

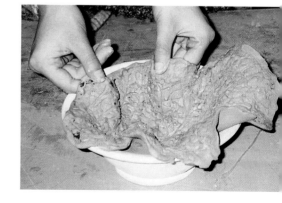

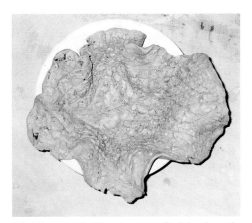

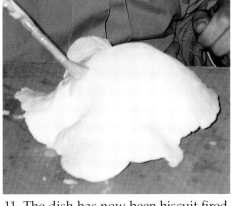

10. The modelling is now finished and the pot is left to dry. When dry, biscuit fire the dish to 1000°C (1832°F), see p.27 for firing instructions.

11. The dish has now been biscuit fired and is now being handpainted with glaze. The outside is done first, and the base left unglazed.

12. The inside of the dish is painted, the varying thickness of hand painting causing the glaze to pool in the deeper areas. This emphasises the structure of the cabbage and its veins. You can dip the dish in the glaze for a more even layer if you want, but make sure you clean the base of the pot thoroughly before firing, otherwise it will stick to the kiln shelf.

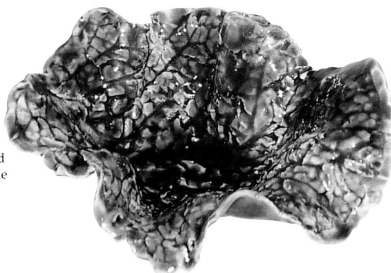

13. The finished pot showing the pooling of the glaze in the veins.

Project 4 • A Plantpot Holder

You will need
• cloth, rolling
pin, wooden slats
• template
(see pp. 66–7)
• cutting tool
• plastic
bag/clingfilm
• slip
• small paint-
brush
• small board
• sponge
• cardboard tube
(or similar)
• plastic flowerpot

Suited to average abilities. Help may be needed extracting the plastic pot from the clay pot. Includes rolling slabs and cutting around templates.

This is a way of using slabs of clay to produce a plantpot holder formed around a standard size garden plantpot. Due to clay shrinkage, the planter will fit a 1in. (2.5 cm) smaller size of plantpot than the slabs were formed around. The shape of leaf came from a coleus houseplant that we grew from seed; this is a good standard shape from which to develop your own ideas.

1. The prepared clay is rolled out on a cloth between two strips of wood approximately ¼ in. (5 mm) thick. The slab needs to be flush with the wooden strips to be an even thickness. (See p.42 for fuller instructions on rolling a slab.)

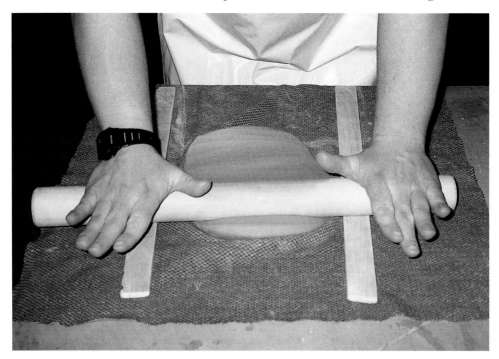

2. Cut around a stiff template, which can be made from card or rigid plastic or, in the case of the picture, an old X-ray plate. Be careful to cut right through the clay or it will tear when lifted.

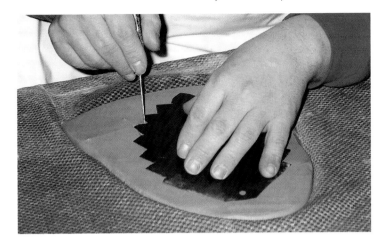

3. Cutting is now complete. Four of these leaves are needed to make one plant-pot holder.

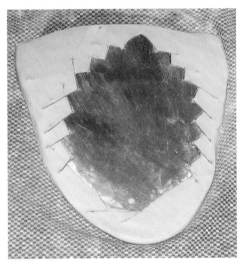

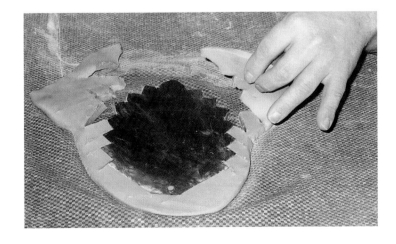

4. The excess clay is lifted away cleanly.

5. *Right* The plantpot is wrapped in plastic (clingfilm or any old carrier bag can be used) so that the moist clay does not stick to the planter and become difficult to remove at a later stage.

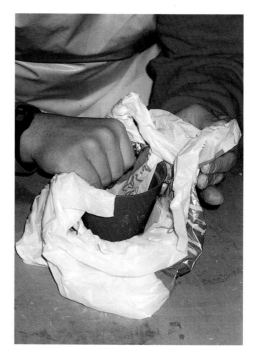

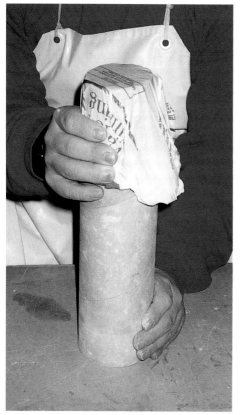

6. The plastic-covered plantpot is placed on a tube or any similar support, so that the leaves of clay can overhang the edge when applied.

7. *Right* The first leaf is placed on the planter, keeping the base steady to prevent it falling over.

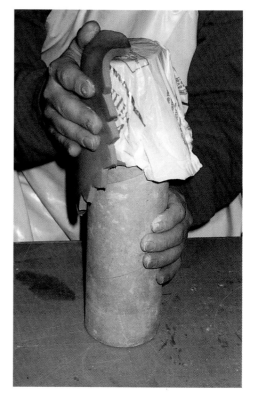

8. The second leaf is placed opposite the first leaf.

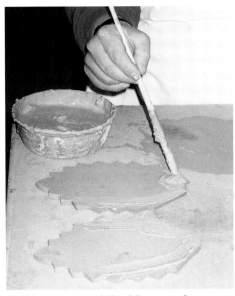

9. Slip is painted thickly onto the edges of the last two leaves to join the whole pot together.

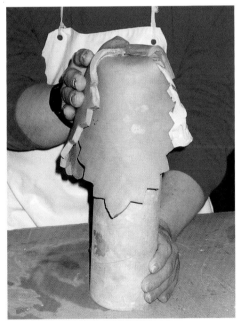

10. The third leaf is applied to the first two leaves, and repeated with the fourth, taking care to keep the leaves level.

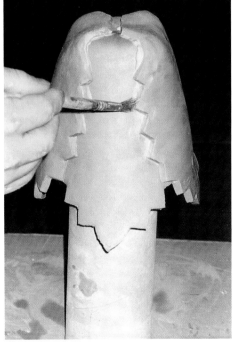

11. Excess slip is cleaned off the joints using a small paintbrush.

12. A board is placed on the base of the pot whilst it is still upside down.

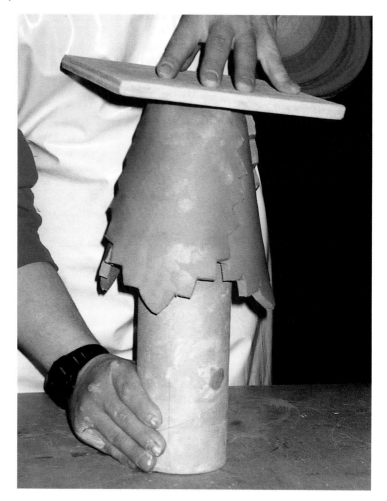

13. Holding firmly onto both the board and tube, carefully turn the soft pot the right way up.

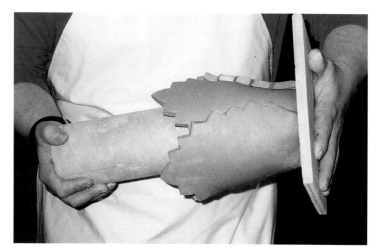

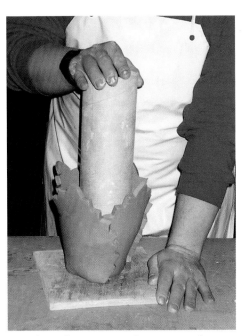

14. The tube can now be removed.

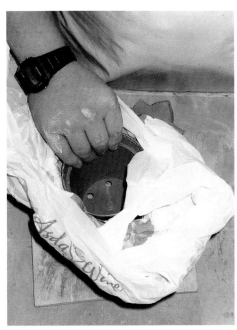

15. The plantpot can be carefully lifted from inside the plastic liner, taking care not to distort the soft clay planter.

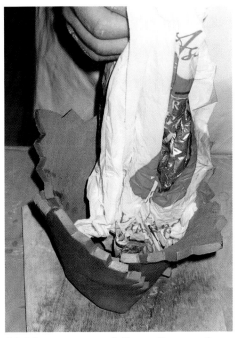

16. Now very carefully pull away the plastic liner, being aware that it some-times sticks.

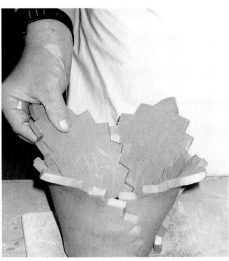

17. Gently bend the leaf tips outward to give a more natural look. The pot must be left to dry until at least leatherhard before commencing the next stage.

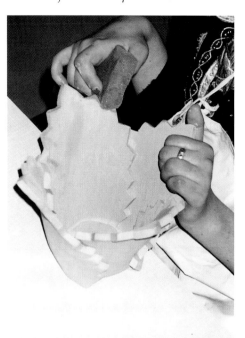

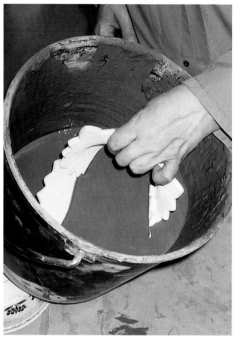

18. Using a damp sponge, gently rub the sharp edges until you have a neat finish. Once the pot is absolutely dry, it is biscuit fired to 1000°C (1832°F), hardening it ready for glazing. See p.27 for firing instructions.

19. Glazing the piece after biscuit firing. Make sure the glaze is thoroughly stirred to the same consistency as single cream. Holding the pot firmly, dip in and out of the glaze. When the wet sheen has disappeared, you can touch up any marks left by fingertips with a brush. Sometimes it is better to dip one half and let it dry and then dip the other half.

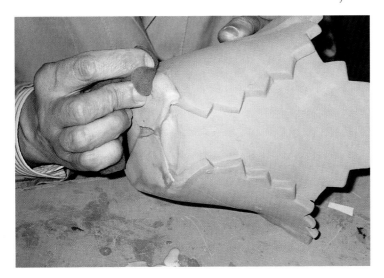

Before all glaze firings you must wipe the base clean and remove the glaze at least ¼ in. (5 mm) up the side of the pot, to prevent the pot from fixing itself to the kiln shelf during firing.

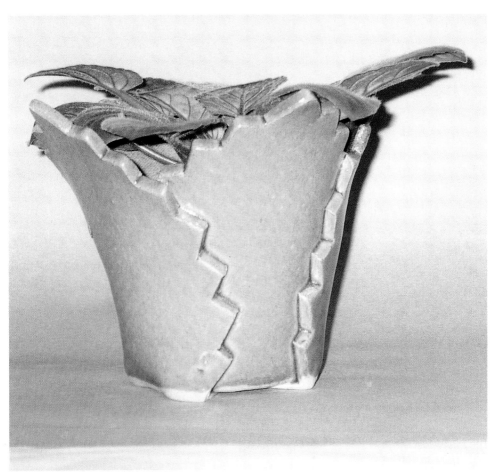

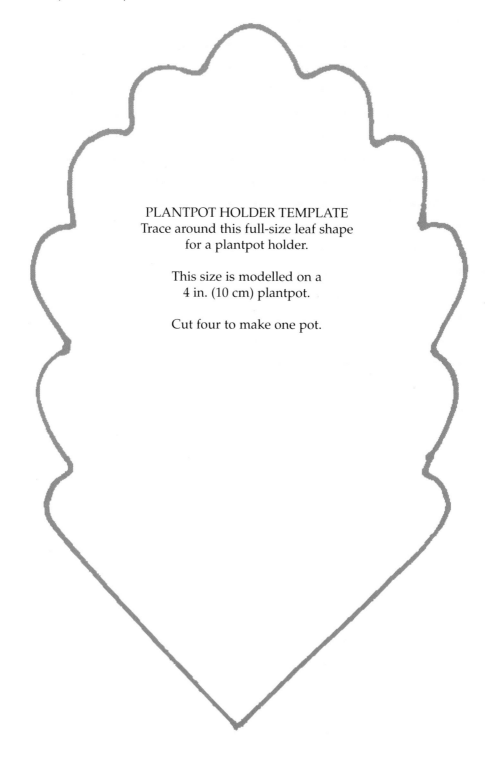

PLANTPOT HOLDER TEMPLATE
Trace around this full-size leaf shape
for a plantpot holder.

This size is modelled on a
4 in. (10 cm) plantpot.

Cut four to make one pot.

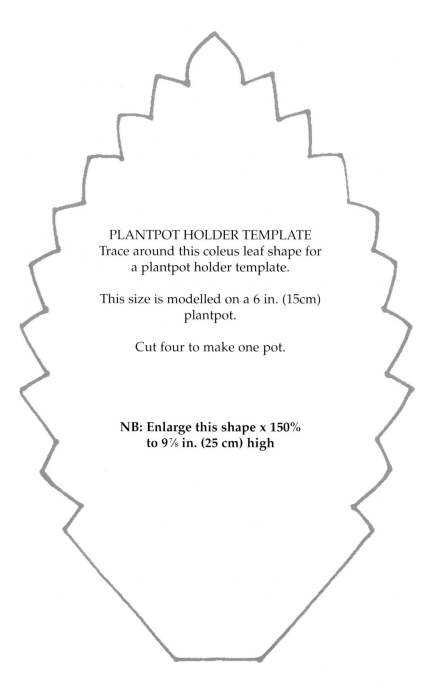

PLANTPOT HOLDER TEMPLATE
Trace around this coleus leaf shape for
a plantpot holder template.

This size is modelled on a 6 in. (15cm)
plantpot.

Cut four to make one pot.

**NB: Enlarge this shape x 150%
to 9⅞ in. (25 cm) high**

Project 5 • The House that David Built

You will need
• cloth, rolling pin and wooden slats
• knife or cutting tool
• fork or surform blade
• newspaper or clingfilm
• cardboard tube (for the circular house)
• cardboard (for house below)
• modelling tools

Below A house made purely from slabs.

This project is for the fairly skilled, but is also beneficial to people who have had a stroke or arthritis as there is a lot of scope for mental stimulation. It allows for great creativity through adding interesting details to the house. It involves slabs, coils and some simple modelling.

This project was designed for someone who had suffered a stroke. He could only use one arm and I had to devise a way for him to be able to do as much of the work himself as possible. He was able to roll a slab of clay so he used this method for the base. For the walls we had to find a different method, as you need the use of both hands to assemble slabs. If the tutor does too much of the hands-on work for the person, it has little benefit for them, in that they will not develop or grow from the experience as much as if they had done it themselves. Personal creativity builds confidence and self-esteem, and physical involvement keeps the body mobile.

If you would prefer a purely slab-built house such as the one below, you need to work out the size and shape of the walls and make templates from cardboard first. This project shows how to make the circular house on the opposite page.

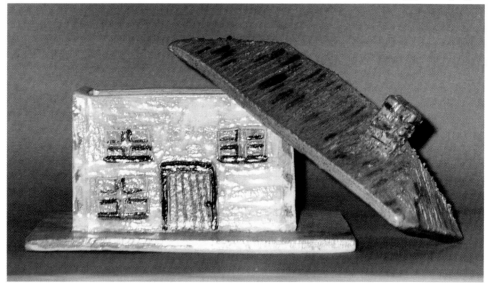

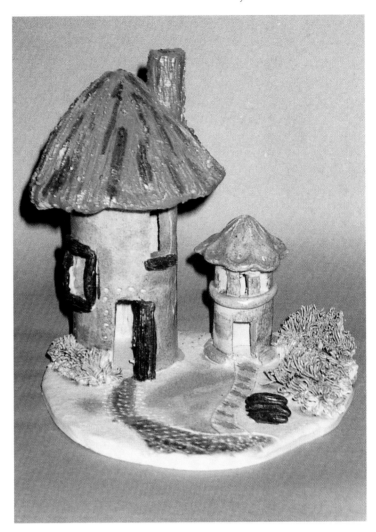

1. Roll a slab for the base of the house. See p.42 for instructions on rolling slabs, and photos on pp.54–5.

2. The solution to building the sides of the house was to use coils of clay, although two hands would normally be needed for this. Instead, we found an old, very stiff cardboard tube that was about 3 in. (7.5 cm) in diameter and 11 in. (28 cm) in height, which we covered in clingfilm. (Newspaper, paper towels or thin cloth will also do.) This was necessary to stop the wet clay from sticking to the tube, which needed to be removed before the clay starts to dry. Clay shrinks as it dries, so it is very important to check your work at the end of a session, ensuring that it is not left to dry onto anything.

If it is, it will shrink and crack. If, however, the clay is placed inside a shape (e.g. a dish) there will be no problem, as it will shrink away from the dish.

The coils of clay can be rolled out by hand (see p.42), basically rolling a sausage shape of clay to about ½ in. (1 cm) thick, or they can be extruded from a wad box or clay bulley (explained more fully in chapter 6 on machinery, see fig. 1). I start the coiling off, around the base of the tube which has been placed upright on the slab of clay, and place two layers of coils one on top of the other and in contact with the side of the tube; this is important as it keeps the sides of the house going straight up. The coils are then smoothed together to join them. This process is repeated until the walls are the required size.

3. At this stage, you decide on the number of windows, doors and decorations you would like on your house. Depending on the person's ability, there are a variety of ways in which you can achieve this: some people may be able to cut out the windows and doors freehand, for others a light outline may be drawn on to the soft clay and then cut out, if a mistake is made during the drawing stage, this can easily be rubbed over without spoiling the house. At this stage, some people may only have enough strength to cut through soft clay while others may enjoy the control of cutting through a slightly stiffer clay.

If you have someone who has difficulty putting the windows in, perhaps being shaky or simply not very artistic or confident, you can always make a little tool with which to impress the clay, leaving the indentation of a window. This can be done in advance from fired clay (see p.15), or you can use appropriate found objects. We made up our own tool from balsa wood, using the skill of a group member who was very talented with his hands. Maximising each person's talents within your group is another positive aspect of team work which has such a beneficial effect.

4. For the roof, we moulded a slab of soft clay around a shallow cone shape similar to a Chinese hat. This was then given the texture of a thatched roof, using the serrated edge of a piece of broken surform blade, or a fork. The roof can be carefully lifted off its mould and stuck on to the walls with slip, or simply placed on the walls and left to dry. It would then be fired in place but remain removable after firing. Just check before firing that the roof has not stuck itself on to the walls.

6. When the house is finished and you are sure that everything has been attached with slip, leave it to dry completely and biscuit fire it. See p.27 for firing instructions.

Afterwards, most people glaze the details, often leaving the walls of the house unglazed to look more natural, creating a pleasing contrast.

Tips

With the decoration, anything is acceptable, although it is important to use clay of roughly the same consistency; a wet piece of clay attached to a leatherhard piece will probably come apart when dry, as shrinkage rates are incompatible. Be sure to score the clay before joining and always use slip!

If you would prefer to make a slab-built building, such as the one shown above, you will need some stiff cardboard. Work out the size and shape of each wall and make cardboard templates to cut around. See also p.93 (Seven Dwarves project) for how templates are used in slab building.

In my years in this work, it has been lovely to see people's imagination develop, starting with basic concepts such as windows and doors, to which are then added window sills, bars, door knockers, letter boxes, steps, etc., and this starts to spill out to garden benches, drain pipes, water tubs, wellington boots, garden tools, cats, dogs, snails, creepers growing up the sides of the house, and even apple and pear trees.

Project 6 • Bonsai Pots Made by a Blind Person

You will need
• cloth, rolling pin and wooden slats
• cardboard or plywood template or ruler
• knife/cutting tool
• slip
• wooden tool
• sponge

This project needs a fair amount of skill, and a steady hand is a bonus in order to join the slabs accurately.

This project was developed because one person in the group wanted to make some weatherproof pots for his bonsai trees. The problem of the pot having to be frost- and weatherproof was immediately solved by working in stoneware, and leaving good drainage holes which is essential for the trees.

We made a start by discussing exactly what was wanted and worked with this end in mind. We knew the finished size needed, and so we made a template, (allowing for 12% shrinkage, and the thickness of the slabs). Obviously if a specific size is not needed this is much simpler. We made a simple pattern in thick card to judge how the pot would look, the proportions and angle of the slant of the side. Once happy with this, we needed to make a template in a harder material, as the blind person I was working with found it easier to feel along a plywood template. When cutting through a leatherhard piece of clay, this plywood template was easy to guide the knife along. For someone who can see, a cardboard template is probably sufficient. Start by deciding on the size of your pot, and cutting out a template.

1. Roll out a slab of clay (see p.42 for instructions) and allow to stiffen up. The plywood template was placed on to the leatherhard slab, the person feeling where it should go. (If it is placed near the edge of the slab, a minimal amount of clay is wasted.) He then felt round the edge of the pattern and began to cut, feeling his knife along the edge of the plywood, and sensing the blade touch the board underneath, so as to get a clean cut. Thick plywood helps keep the knife at a right angle to the clay.

2. One slab has been cut, this needs repeating three times to make four slabs for the four sides.

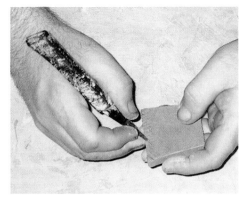

3. All of the edges that are to be joined will need cross-hatching on the surface, where they will touch. This was achieved quite easily just by feeling for the edge and scratching in to the surface with a pottery knife, and I advised whether to cut deeper or shallower until he knew himself the correct depth to go.

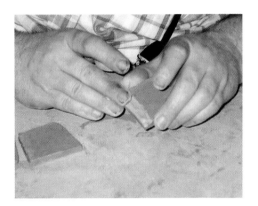

4. *Left* Applying the slip was done by touch again; my input was minimal here as he felt more confident judging the amount that he was using.

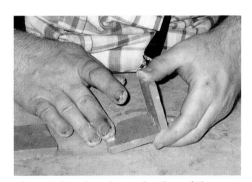

5 & 6. Assembling the first slabs, the slipped sides of the pot were pressed together. Aligning the sides caused no problems, but he found it hard to judge which way up the slabs had to be, as the pot slanted from bottom to top (being narrower at the bottom). I observed the process, and said when he had the slabs correctly positioned.

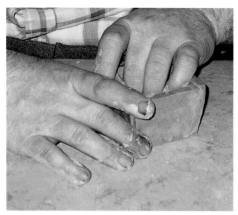
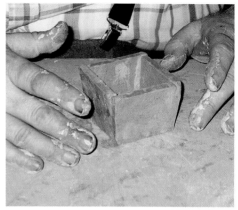

7 & 8. Smoothing down and checking the inside edges to ensure the joints are secure. The box is now ready for its base.

9. The pot is now in place on the base slab and this is cut to size.

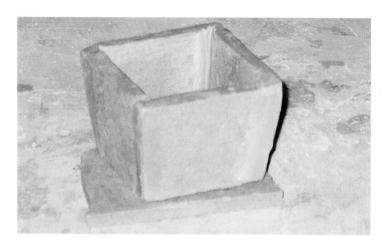

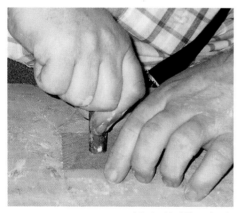
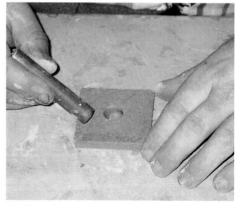

10 & 11. The drainage hole is being cut out of the base slab using an old piece of copper pipe.

12. The clay is cross-hatched where the sides and base will meet and slip is applied. The top is then placed on to the base, and is slid into place using touch.

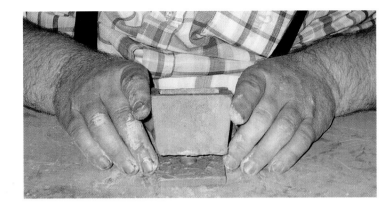

13. The sides are tidied up with a smooth wooden tool. Little assistance was required at this stage.

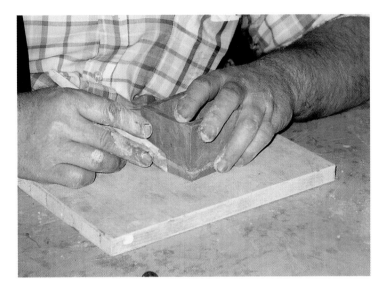

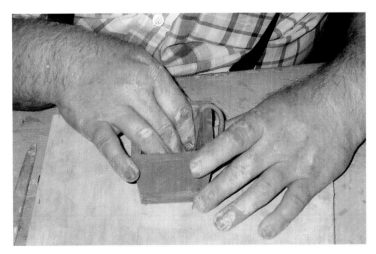

14. A thin sausage of clay is smoothed in the corners to reinforce the joints. Once the pot had dried a little more, I sponged it over before it dried out ready for the biscuit firing. See p.27 on how to fire.

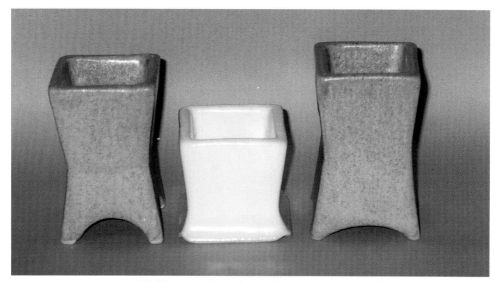

15. These various bonsai pots were dipped to get an even glaze, but we developed an easy system for glazing which involved painting the glaze on in a systematic way so as not to leave any bare patches. The feet were thoroughly cleaned before the glaze firing.

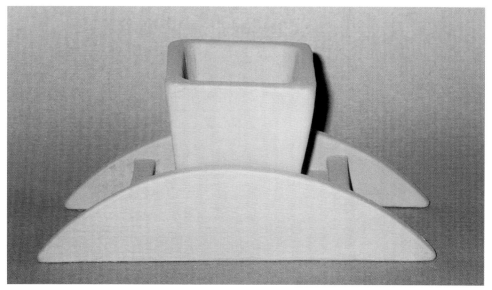

16. This illustrates another idea, where we made a stand for the pot. We painted a layer of terracotta clay on to the leatherhard pot, and only biscuit fired it, to retain the attractive colour. However, in this state it will not be water-tight, or frost- or weatherproof.

Project 7 • A House Number Plaque

You will need
- cloth, rolling pin and wooden slats
- Cardboard template (see pp. 81–2)
- cutting tool
- number templates (can be rubber, wood or biscuit tools, see p.15)
- mould of acorn (optional)
- slip
- sponge

Average ability needed for this project. Involves rolling slabs, and successful plaques are the neatest ones!

The house number plaques have been a really useful project, as they are good enough to use, are completely weatherproof, and will not crack in the frost (as long as they are made in stoneware). Although parts are unglazed, they keep looking good as the rain washes any dust away. The example I use here is the most popular design, although it is just one of many. Over the past few years we have created a wonderful selection, and they have included other leaf-types of which maple was very popular. I kept a folder of different templates that I knew would work well for a number plaque, from which people could choose. This basic project inspired people to make decorative plaques for indoors as well, and commemorative plaques were made for special birthdays and anniversaries. It allows for much creative freedom as working on a slab like this and adding decoration does not present a lot of technical problems. Many of our group were football fans, and as we were based between two rival teams, there was a lot of healthy competition; this resulted in an abundance of football plaques and I was very often asked to drawn the world cup on a plaque.

1. Roll out a slab of clay for the plaque, ½ in. (12 mm) thick is good, as it is less likely to warp and crack. Roll out your slab on the cloth between the wooden slats (see p.42 for more details on rolling slabs).

2. A template for your plaque is placed on the slab and then cut around, making sure that the blade goes all the way through the clay. If not, the excess clay will tear and leave a messy edge when peeled away.

The excess clay is carefully lifted away. Notice how the leaf stays flat and the cut edge comes away cleanly.

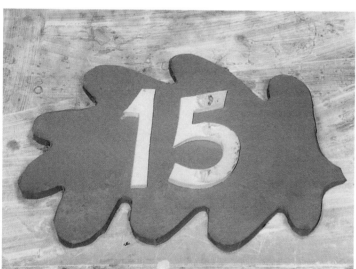

3. The leaf with the number templates in position. These numbers were made by me out of clay and then biscuit fired, allowing them to be both hard and porous, so less likely to stick when pressed into the clay.

These number stamps are then evenly pressed into the clay to leave an impression. Be careful not to press them in too deeply, as the outer edge of the leaf is likely to crack.

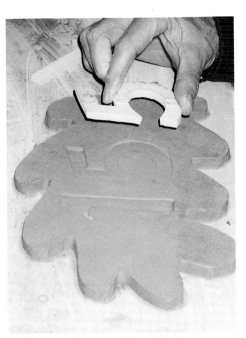

4. The numbers are then lifted away, leaving an impression behind.

5. To make the decorative acorns we used a press mould, (i.e. where a piece of clay is pressed into a mould). If you have not made a mould in advance, you can model an acorn from a small ball of clay, using a wooden tool.

6. The top layer of extra clay is cut off across the flat surface of the mould; care is needed here so as not to cut into the soft plaster as it will damage the mould.

7. The acorn shape in the mould is then eased out, using a small piece of clay stuck to the back of the acorn. This may take a little practice at first.

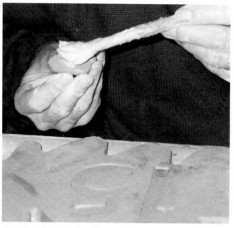

8. Slip is applied to the back of the acorn (mould-made or hand-made).

9. The acorn is placed where you want it on your leaf.

10. Two holes are put in for the screws; these need to be about ⅜ in.(1 cm) wide to allow for shrinkage and for the right size screw to hold the plaque securely on the wall.

11. When the plaque has dried the edges will need rubbing down with a wet sponge to give a smooth finish to the edge, and the screw holes will need checking to ensure that they are clear. Take care, as the piece will be very fragile at this stage.

When the piece is thoroughly dry, it can be biscuit fired (see p.27 for firing instructions).

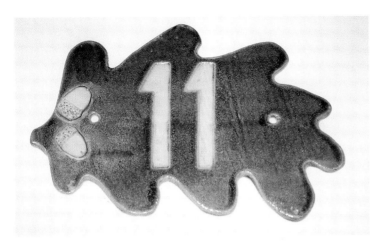

12. A finished plaque.

After the biscuit firing the plaque can be glazed. I recommend simply dipping the plaque in a glaze, or brushing the glaze on, then the numbers and the acorns can be cleaned of all glaze, so that when fired, they have a lovely toasted, stony, matt colouring. Great care must be taken to make sure that the screw holes are free of glaze, and that the glaze is completely cleaned off the underside, and ¼ in. (6 mm) up the side. This is to make sure that no glaze can come into contact with the kiln shelf and stick to it.

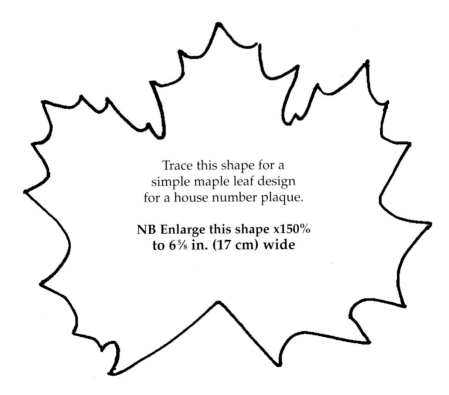

Trace this shape for a simple maple leaf design for a house number plaque.

NB Enlarge this shape x150% to 6⅝ in. (17 cm) wide

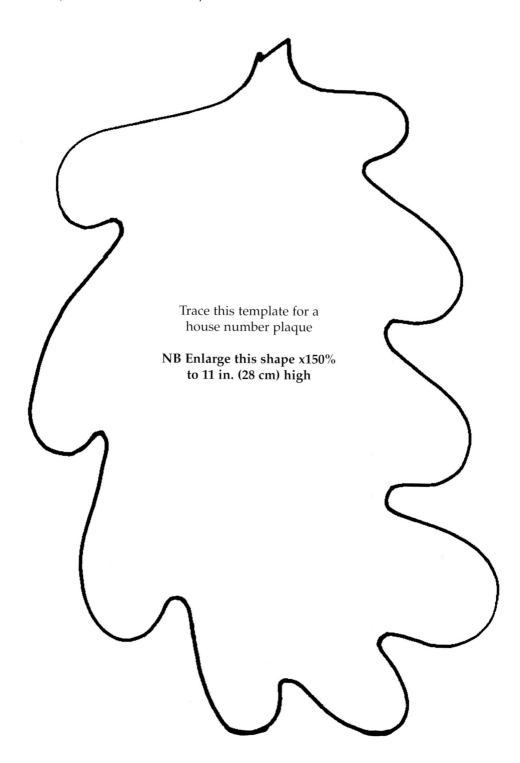

Trace this template for a
house number plaque

**NB Enlarge this shape x150%
to 11 in. (28 cm) high**

Project 8 • A Rose Bowl

You will need
• cloth, rolling pin and wooden slats
• bowl
• tissue paper
• carboard or plywood template for leaves
• knife/cutting tool
• pointed wooden tool or sharpened pencil

This project is more suited to the physically disabled and people who have had a mental illness; it is very good for concentration. The fairly fine work requires thin and thick slabs.

The rose bowl has been a real favourite for many years and we have had many sociable lessons making them. It often attracts a lot of the older ladies who may have problems walking, or problems with their shoulders, or difficulty concentrating for very long, and if there were any physically disabled people who were less able to join in with the making, they enjoyed being part of the group, watching the activity, and offering a valued opinion on how the work was progressing. People who have arthritis can sit comfortably and cope with the limited degree of movement and strength needed to make the rose petals and assemble the flowers, the movement of the fingers being very important to keep them supple and useful. Some weeks someone might not be capable of handling their work, but could carry on a week or two later. As long as the roses and leaves they had made from week to week were kept in a carton labelled with their name, it did not matter that they had dried out. The roses can be assembled in the bowl once glazed; they need to be carefully handled at this stage, as they are very brittle when dry.

The roses were used on other designs and pots as people came up with their own ideas. One woman made a simple log out of clay, textured it with a dinner fork, made a hole for a candle, then arranged her rose and a few leaves next to the candle hole. It was beautiful and inspired the others to develop their own ideas, one of which was a log with Christmas decorations but designed with holly and berries instead. Another woman made a simple vase by wrapping a slab of clay around a rolling pin and sealing it onto a base, this being a perfect object to decorate with her roses, as the plain vase did not distract from the roses but gave them a well-designed base.

Making the bowl

The bowl is made in the same way as the top for the garden mushrooms, rolling out a slab of clay following the instructions in the garden mushrooms project, and laying the slab in a biscuit-fired bowl. I like to pinch the edges in an undulating fashion, giving a wavy edge which suits the roses.

False bottom in place

1. The edges are pinched to give the wavy edge.

2. A false base is often needed to elevate the flowers as they will sink down in a deep bowl, this is achieved by cutting a circle from a slab of clay that will rest in the bowl at a suitable height for the roses. This slab will rest in the bowl without having to be stuck in place. This diagram shows the false base in position.

Another type of bowl can be made in the same way as the tortoise bodies are made. Follow the instructions as described in the Tortoise project. Once the bowl is made, place it on the working surface and gently tap it down, to give it a flat base. This dish also usually needs a false bottom.

Making the roses

Roll a ball to the approximate size of a Malteser using fairly soft clay, then press it out evenly until it is about ⅛ in. (3 mm) thick. Squeeze around the edge until it looks paper thin – this makes the petal appear delicate although it is in fact robust, as the centre is thicker. The most difficult stage follows: rolling the first petal. Don't worry if you are having to roll a lot of people's first centre for them, as this is quite a skill in itself and needs practice. If it is one of the first petals someone has done it is likely to be too dry to roll such a tight curve on the petal. Always make sure the petal for the centre is soft and you are more likely to be successful.

3. The centre is rolled between first finger and thumb. The next petals are flattened in the same way and added by gently pinching them to the base of the centre.

4. The position to which you attach the next petal. Position the petals, overlapping the previous one by about a half, and keep going round. The outer petals can be made with slightly larger pieces of clay to get the effect of the larger outer petals.

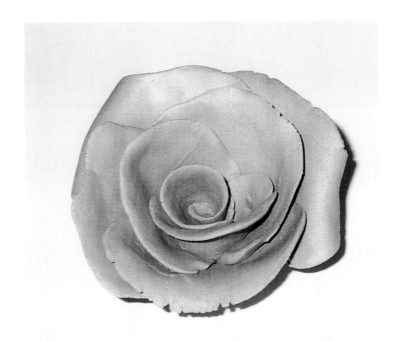

5. The finished rose.

Some people may not be able to pinch the clay in this way, so we make the ball as usual, then press it into the middle of one hand with the heel of the other. The thumb is also very good for this. This method makes a very good petal, with the imprint of the lines of your hand on it. This enhances the texture of the surface, making it quite naturalistic.

6. This photo is of one of my group who could not manage either of these ways, and so we found a way round this by squashing the balls of clay onto a paper towel (to create a non-stick surface). She used the side of her hand to flatten the petals, and I assembled the roses for her, as she had not got the strength and could not get her hands into the correct position to assemble the pieces. This did not stop her from helping with making the bowl and glazing it all herself, as well as getting plenty of requests for them!

Making the leaves

The leaves are made from a very thin slab of clay. When rolling out the slab, two strips of ordinary hardboard should be about right for gauging the thickness for this project. You can arrange the roses and leaves as you want; I usually lay

7. Cutting around the template.

8. The excess clay is carefully peeled away.

9. The edges are squeezed to make a thinner looking edge, leaving the centre thicker and stronger.

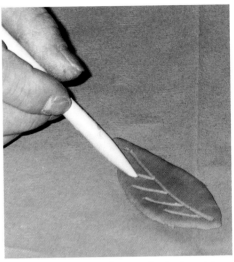

10. The veins are drawn in, but not too deeply, with a wooden tool.

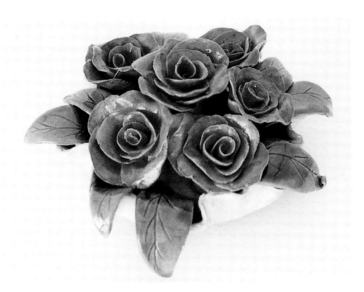

11. The finished piece.

some leaves around the edge slightly overhanging the side of the bowl, then fill in with the roses, just putting the odd leaf in here and there.

These are then left to dry completely before being biscuit fired (see p.27 for firing instructions). After this first firing the glazing is best done by painting the glaze on by brush and then firing again, following the instructions on glaze firing (see p.30).

5. Hand Modelling

Making a Labrador

You will need
• knife/cutting tool
• modelling tool
• tablespoon or teaspoon
• plastic bag/ clingfilm
• wooden board, such as old chopping board (to work on — optional)

Hand modelling is the sort of work anyone can try. The possibilities are endless. In my experience, a lot of people tend to want to model something representational, and the important thing for this is to look closely at whatever it is you are trying to model. One of the women, for example, wanted to model her beloved labrador. She was fairly good at modelling, and so we started by looking at some of her photos.

The model of the labrador took several sessions to complete and we started with very soft clay for the initial work and then let the clay stiffen a bit. When the clay hardens (becoming leatherhard), we use slip for joining it together.

It can be beneficial to work for a while and then have a break, as you come back to the work refreshed and optimistic. The concentration required is tremendous, and can be quite tiring. For people with mental illness, this concentration can be very positive, absorbing their whole focus. Added to that is the bonus of learning a new skill, and a physical object to be proud of — a positive reinforcement of success.

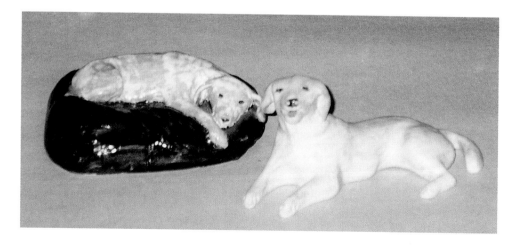

1. The first thing to decide on is what size you want your piece. We decided on a size of about 7 in. (18 cm) in length, and cut the clay roughly to size.

2. We then started to model by cutting away the clay where needed and adding pieces where needed; these pieces that are added are very soft clay and are pressed on firmly, so there is no need to use slip. This is basically how you progress, until it starts to take shape.

3. When you have got a rough idea of the shape, and before it has got too detailed, turn it upside down and scoop out some of the excess clay with a spoon from underneath where it will not be seen. Allow about 1 in. (2.5 cm) thickness of clay to work with. This will reduce the thickness of the piece and prevent it from exploding in the kiln.

4. Keep looking at your subject and measuring, checking it is the right proportion. The most important thing you can do is to keep looking at your subject, as you can get carried away with elements of very enjoyable modelling, and when you look at your subject again you have lost your way and will have to remodel that very same part.

5. When you have finished the session, and want to carry on with the work another day, wrap it up thoroughly in plastic (a bag or clingfilm). If you want it to harden a little for the next stage of modelling, leave it out and keep a watchful eye on it, checking it often, until it has reached the correct consistency. It can then be wrapped. Finally, once the piece is finished, allow it to dry and see p.27 for firing instructions.

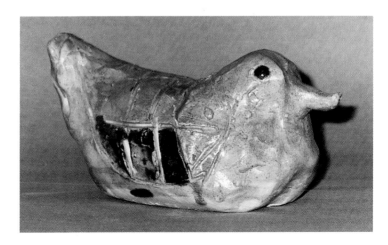

Hedgehogs and Sheep

Hedgehogs and sheep are very popular for all to model. They also work well for groups to do together, the less able can do the basic shape and expressions on the faces, and the more able can do any joining and add the prickles.

They are very simple, made of a basic oval shape hollowed out, with an air hole for expansion. The hedgehog was so popular at the day centre that I made a simple press-mould to make the two halves of the body: the rounded back end and the front end containing the shaping for the nose. These only needed attaching together with slip, and an air hole made into the body. The prickles were then added. If you want to make a mould for the hedgehog, follow the instructions on how to model it (before adding prickles), and then turn to p.108 on how to make moulds.

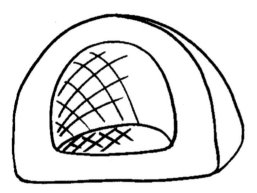

Plaster mould of back end of hedgehog for pressmoulding.

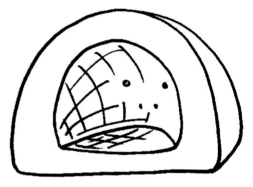

Plaster mould of front end of hedgehog for pressmoulding. Note the four little dots, showing a simple face.

Pressmoulded shapes, now out of the mould and ready to be joined together with slip.
NB Once the edges have been joined, make sure that there is a hole underneath to let the air escape from the centre of the piece when firing.

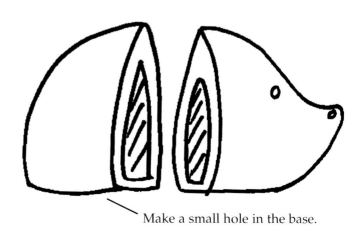

Make a small hole in the base.

Hedgehog

You will need
• pressmould
(optional)
• sieve
• knife
• slip
• brush
• small
board/wooden
base (e.g. old
chopping board)
– optional

1. The hedgehog needs a basic body shape to add your detail to. To make the hedgehog (without a pressmould), start by taking a ball of clay roughly the size of a tennis ball (a good size to start on), and roll it in your hands into an oval, almost the shape of a short bread roll.

2. Holding your oval in one hand, use the other to smooth the clay into a pointed nose shape. It is a good idea at this stage to scoop out some clay from underneath the body, leaving the hedgehog about ½ in. (12 mm) thick. You may want to add the detail once the hedgehog is on its board, so you will not have to pick it up at a crucial moment.

3. To make the face, roll a little ball of clay about ⅜ in. (1 cm) wide, apply some slurry and join it to the end of the nose. Roll two more small balls of clay, apply slurry and position for eyes. At this point you can add lots of detail if you want to, giving the hedgehog a character, with a big smile and long eyelashes, or beard and hat, or whatever ideas appeal.

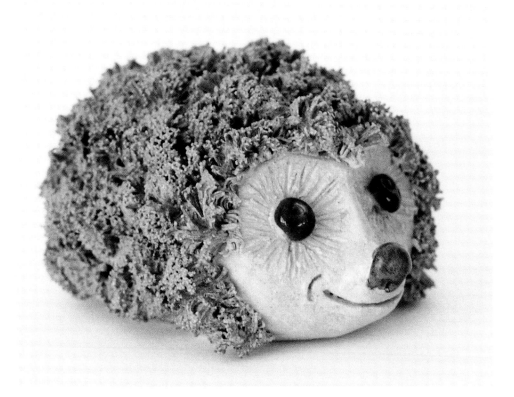

4. Before adding prickles, the body of the hedgehog is first covered with slip so that all the tiny prickles will bed in to the slip and stick to the body.

5. To make the prickles for the body, push the soft clay through a sieve (an ordinary kitchen sieve will do) before carefully cutting off the clay 'prickles' with a knife. Make the hedgehog on a board, as you may find it difficult to pick up to move it once the prickles have been attached; if you apply any pressure to them they will flatten down, losing their effect. You will only be able to handle them once they have been fired, as the prickles will crumble if you try to handle them when bone dry.

6. The hedgehogs can be carefully picked up by their noses at this stage, but the sheep do not have a large area of flat clay to handle, so are more tricky.

Sheep

1.The sheep are modelled on an oval body form. The sheep also needs a basic body shape. Start by taking a ball of clay roughly the size of a tennis ball (a good size to start on), and roll it in your hands into an oval, almost the shape of a short bread roll. Once satisfied with this size and shape, turn it upside down and hollow out some of the excess clay from underneath, leaving about 1 in. (2.5 cm) thickness of clay.

2. The head is modelled separately, and this is when you can really go to town on the character. We have loved doing faces with quizzical looks and funny facial expressions, adding majestic rams' horns, curly fringes, pipes being smoked, spectacles and anything else we could think of at the time.

3. The wool is made in the same way as the hedgehog prickles. To make the 'wool' all over them squash very soft clay through the sieve, and cut the wool off with a knife. Cover the body with slip and then embed the wool in the slip. Try not to squash it down too much or you will lose all the detail.

4. Leave the sheep to dry thoroughly and then biscuit fire. See p.27 on how to fire.

Tips

All the modelling went on to be glazed as desired, but in the past I have had people who have wanted very bright colours to get the effect that they want. We have solved this problem by firing the unglazed pot up to its glaze temperature, before painting it with poster paints, and then painting a sealant over the top when dry. A clear varnish or one of the P.V.A. glues that are used for woodwork or general art work are suitable. Alternatively, for normal glazing, see p.118.

The Seven Dwarves

You will need
- see pp. 100–102 for templates
- cardboard or similar (for templates)
- cloth, wooden slats and rolling pin
- knife
- slip
- modelling tools
- small paint-brush
- sieve (optional)
- plastic bags/clingfilm

A large project for the more able, very relaxing for those who like modelling and detail.

It may well take several sessions to complete, so you will need to wrap up the work in plastic between sessions.

One person in the group liked to do figurative pieces: a wonderful example was her interpretation of the seven dwarves in bed. This was a basic construction of a box shape made of leatherhard slabs with headboard and foot-board on a floor area; each individual dwarf was made and laid on the bed with a pillow under the head, and a soft slab was laid over them like a blanket. The great pleasure came in the details, which developed effortlessly: a great array of different worktools were hung on the footboard, spread on the bed and scattered on the mat; the mat was also home to a great variety of dwarves' slippers and work boots, crumpled socks, and a chamber pot completed the piece.

1. Roll out a couple of large slabs of clay, and cut them into five sections to make the bed, using the templates on pages 100–102. Photocopy or trace out the templates to cut around. Alternatively, if this is not possible, it will need four long thin slabs, approx. 2–3 in. x 8 in. (5–7.5 cm x 20 cm) and one large slab, approx. 5 in. x 8 in. (13 cm x 20 cm).

2. Before starting to construct the bed, allow the cut slabs to stiffen up. They should be leatherhard as this will prevent the bed from collapsing! This type of construction will not work with very soft clay.

The two thin strips (slabs B) make the sides of the bed. Join these to the top of the bed (slab A) first. In order to join them, lightly score the edges to be joined with a knife, (or use an old toothbrush to get a good joining surface), and apply slip using a paint-brush. Press the sides onto the top firmly. The top of the bed with its sides will be upside-down at this stage (as in the photos).

3. Once the two sides are attached, roll out a thin coil to reinforce the joins with.

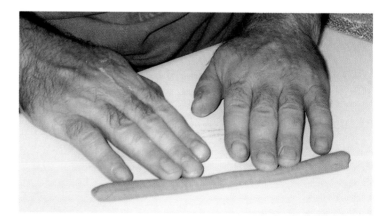

4. Apply the coil to the inside of the join to strengthen the support.

5. Next, score the edges of the base and the bottom of the sides, and apply slip. Then join the top and sides to the base (panel D).

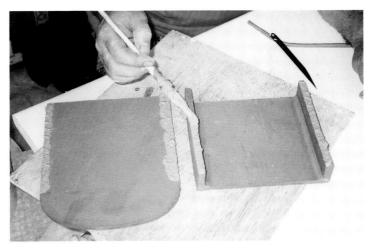

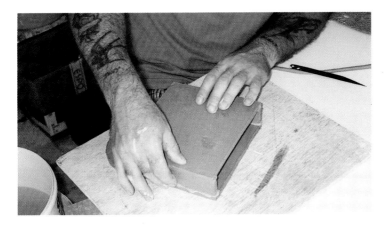

The base will stick out an inch or so (2.5 cm) from the end of the bed. This space can be used for adding details and decorations such as boots, tools, books (or any ideas you have!).

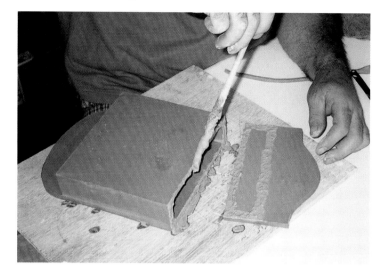

6. Lightly score the edges at the top of the bed, and score the surfaces on the headboard (panel E) where it will join it. Apply slip as before, and press the headboard into place. Do the same for the footboard (panel C).

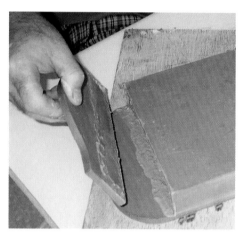

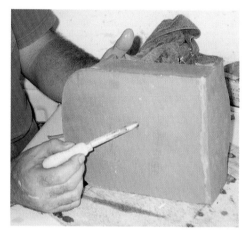

7. Lift the bed gently onto one side and make a hole in the bottom to allow air to escape.

8. If you want some pillows, make small pillow shapes from flattened sausages pinched at the ends.

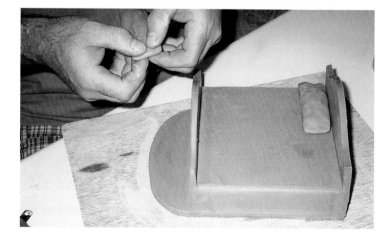

9. Once your bed is made, cover it in plastic while you make the dwarves. Make sure you have made the hole underneath (see stage 7)!

For the body shape roll some soft clay into a sausage shape about 2 in. long (5 cm) and 1 in. (2.5 cm) thick. This will make a nice body shape to lie on the bed beneath the blanket.

10. Next, roll a ball of clay about 1⅛ in. (3 cm) across for the head.

11. For the eyes, you can either roll tiny balls of clay and stick them on with slip, or use a pencil to poke holes. Make the eyebrows using tiny coils and stick them on with slip, or use the pencil again.

12. The mouth is a very expressive part of the face, and again, there are any number of variations you can do to create expressions of surprise, happiness, sadness, singing, shouting etc. Use a thin coil of clay or a pencil to create the mouth.

13. The nose can be wonderfully varied for each dwarf. A small ball of clay can be shaped and stuck on for a button nose, or make it pointed, crooked, turned up, or shaped like a boxers or boozers nose.

14. By sticking small bits of clay on, or modelling them on the face, you can also add teeth, short or long droopy moustaches, goaty beards or large bushy beards with eyebrows to match. To make hair and beards you can use the sieve. Push very soft clay through a mesh sieve (as in modelling hedgehogs), and then cut it off with a knife, or model hair with tools, or create it from thin coils of clay. Remember to use slip when attaching extra things.

15. Most of the body of the dwarf will be under the blanket, but you could add some bits of clothing to the parts that are showing. If you want to add a nightcap to the head, cut out a thin triangular slab of clay and wrap it round the head with the join at the back, so it will not be seen. Extra bits of clothing can be added to the body also, such as a nightshirt collar, or whatever takes your fancy.

Remember to use slip when attaching extra things to the head and body. These joins can then be tidied up using a small paintbrush.

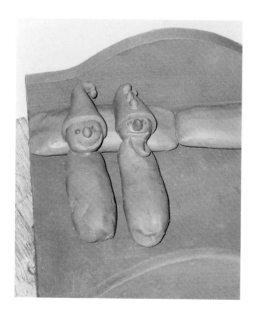

16. As each dwarf is finished, score the bed surface lightly and apply slip before lying the dwarf in its bed. Once you have all seven dwarves in place, roll out a very thin piece of soft clay, and using some slip, lay it carefully over the bodies of the dwarves. Press it down very softly to ensure it is attached.

You can add any further details now, such as books on the bed, boots and clothes on the floor or on the bed ends, feet sticking out of the blanket, etc. These are just suggestions, students will have many of their own ideas once they get started!

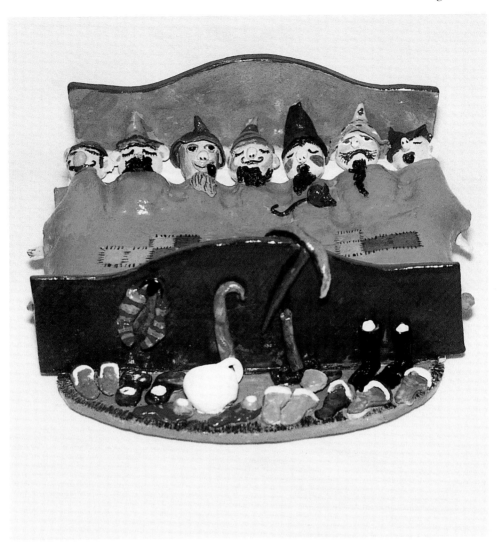

Tips

These sort of pictorial works really come to life with the application of glaze, or paint. Glaze colourings can be difficult to envisage as most do not reveal their final colour until they come out of the kiln. As an alternative, acrylic paints are very good on fired pottery and give a fairly tough finish. They can be left for a satiny effect or coated for a gloss finish. They are particularly good for this kind of project as they can be painted on in great detail. After the biscuit firing, fire the work up to its final temperature (see p.27 for firing instructions), paint the work, and allow to dry. It can then be varnished with a clear varnish if wished.

Panel A (Top): pattern for top of bed. Cut one. Enlarge x 2 to 6¾ in. (17.2 cm) wide.

Panel A

TOP

Panel B SIDE

Panel B (sides) template. Cut two. Enlarge x 2 to 6¾ in. (17.2 cm) long.

Panel C FOOTBOARD

Panel C (footboard) template. Cut one. Enlarge x 2 to 6¾ in. (17.2cm) wide.

Panel D (base)
template.
Cut one.
Enlarge x 2 to
6¾ in. (17.2 cm)
wide

Panel D

BASE

Panel E

HEADBOARD

Panel E (head-
board). Cut one.
Enlarge x 2 to
6¾ in. (17.2 cm)
wide.

HEADBOARD

SIDE

TOP

SIDE

FOOTBOARD

BASE

Here is a rough layout of the panels for the construction of the bed. The base is longer than the end of the bed to allow some space for adding details. See photograph on p.99.

You will need
• cloth, wooden slats and rolling pin
• shapes/objects to press into clay (see project for suggestions)

Abstract Pieces

This is a very simple method of creating interesting objects for anyone of any ability. If the slab is made with two holes at the top, it can be hung up (once glazed) as a fabulous wall plaque.

The photograph that looks like a rock face (see below) was a piece of work by someone with quite severe learning disabilities. It shows how a very simple action can produce a beautiful piece of work. The favourite activity of one person in my group was to bang the clay with a stick, and he used to sit back in his chair, relaxed, and just bang the clay all through the class. I noticed what beautiful patterns were emerging and so I rescued some of these and fired them. He was pleased to see them fired, and then painted several layers of glaze on the piece — the result was very special. I feel it is very important to see opportunities in what people do, however little, and with a bit of organisation and finishing off they can achieve really superb work. The more artistic freedom can be encouraged, the more frustration and stress can be dispelled.

A variation on this idea is to roll out a slab about $\frac{1}{2}$ in. (12 mm) thick, 1ft (30.5 cm) square, this size will allow for freedom of design and pattern. Using bits of evergreen with feathery ends, or tall wild grass, and leaf shapes, use these to press into the clay, creating an interesting plaque. It can be covered in pattern, or have just a few simple marks. Make two holes in the top two corners, and it can be hung on the wall after glazing as a wall plaque. The glaze will

pool in the deeper areas and give lovely results.

Using the same method, this same idea can be repeated with all manner of interesting objects which can be brought in or which the students can collect (if possible), such as shells and pebbles, or rough textured items such as bark, or even food such as pasta (in interesting shapes) or rice. All of these can be pressed into clay to create patterns or abstract designs.

Try to remove all of these objects before they go into the kiln, as they will create fumes as they burn!

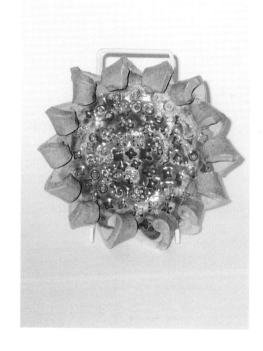

Making Pots from Coils

Traditionally coil pots that are built freehand (that is without a former to support the walls), need some skill and control if you want to achieve a symmetrical shape. I rarely start anyone on this, as they can easily become despondent when their first attempts do not come up to expectation. When the coils are built up against a form, however, and there is some help from the support, results are very different.

1. It is easy to make lovely flower vases very simply and easily, by building the coils round a large stiff cardboard tube, about 3 in (7.5 cm) in diameter and over 1 ft (30.5 cm) tall. To prevent the coils sticking to the card, wrap clingfilm or paper towels round the tube.

2. The prepared tube is best stood on a slab of clay to start with, so you can start smoothing the coils to the base as you start coiling. Roll out a slab, it should be at least ¼ in. (6 mm) so that the base will be strong enough. The base should be wider than the tube, so that there is a ½ in. (12 mm) of clay around the tube. The coils are then built up from the base.

3. Roll out each coil (see p.42 for how to roll a coil), brush slip onto the base and add your coil. Smooth the first coil onto the base, and make sure the ends meet and join together.

4. Build up your pot by adding each coil to the last, one on top of another,

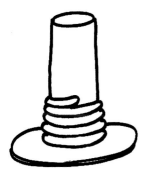

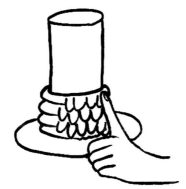

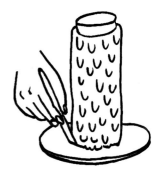

Diagram 1. The coils being laid around the tube directly on top of one another; this is important as it keeps the pot straight. The base is wider than is needed at this stage.

Diagram 2. When about three coils have been laid around the tube, you can start joining them together. It is important to be conscientious with this, as if the joints are not secure they will open up in the firing. Use a finger to push in and down to join the layers, combining the surface of the coils. Joining the bottom coil to the base needs extra care as this is a weak spot that may get neglected.

Diagram 3. The coils are taken to the height required and the top neatened off; the base now needs trimming with a knife and the excess slab of clay peeled away.

smoothing them together as you go. Work up the tube, using it for support.

5. After the pot is completed, but before it has dried, the tube can be eased out. The clingfilm or paper can be left in, as it will burn away in the firing. Make sure there is ventilation around the kiln when you do this.

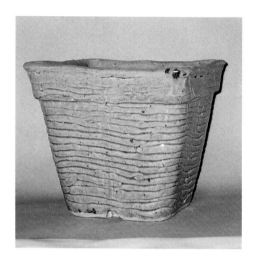

A finished garden pot, glazed and fired. This one was built around a peat mould.

Tips

This is a very straightforward process and a lot of variation can be added. You can smooth the surface completely, or leave the texture of the joined coils, with its natural variation. You can model on broken branches or knot holes, or tree fungus, or you can simply draw into the surface with a fork as you would with icing on a cake.

A good idea that came up was to make garden pots using a peat pot for the mould. A slab is placed in the base of the peat pot and cut to shape, and the coils are then built up on the inside wall of the pot in the same way as the flower vases; if drainage holes are needed they are cut in as soon as the pot is complete, and as there are drainage holes in the peat pot you can follow these for guidance. The pot is then left to dry in the peat pot, where it will shrink away from the sides as it dries so that you will be able to lift it out for firing. Check if the outside needs sponging to smooth off any rough edges before firing.

6. Mould Making and Slipcasting

Introduction

As I was trained at a college with an industrial bias, I was quite at home making plaster models and slipcasting. During my time working in a day centre we made simple moulds and cast pots with much success. Some of the group were very good at modelling and would be asked to do various commissions from time to time; one of these was a pig and it proved so popular that we decided to make our own mould and cast from it. The basic shape was modelled and kept streamlined and simple, to avoid too many undercuts and to keep the number of mould pieces down. The tail and ears were to be added on when the pig came out of the mould; for the ears we made a press mould and these were attached to the body with slip; the tail was a small piece of clay rolled into a point, curled round and attached in the same way; the eyes were two tiny holes poked in. The smaller they were the better they suited the pig. The mouth was then drawn in as a simple line portraying a smile. These pigs were tremendously popular and provided plenty of glazing for the less able to do; this always seemed to work well as the pigs were then decorated in a free and unself-concious style

which always looked more convincing than those more carefully painted.

From the pig followed many more ideas and requests. A cockerel was made next; it was kept simple and looked complete when it came out of the mould, but there was opportunity to add extra feathers on the tail and more detail on its head. A dove was then made with its feathers splayed out at the back; it was fairly stylised and people enjoyed glazing it in the style of a peacock.

One of our very successful projects was a noughts-and-crosses board. In the games cupboard we had some wooden noughts-and-crosses boards that were regularly used but were not very substantial, and were also a bit fine for some people to pick up easily, so we had a go at making our own. The main considerations were that the pieces should be large enough to handle easily, especially for people struggling with arthritis; that they should have raised divisions so that people who could not see very well could feel where to put their pieces, without wiping their opponents' pieces off the board; and they should be easy to make. This was a successful idea, and some visiting physiotherapists who worked with blind people were very keen to use the boards. We

made many of these, and the orders started coming in, largely from people wanting gifts.

Mould making and slipcasting can be simplified but it does take practice and dedication, and does not produce results as quickly as the other projects in the book. But you may be working in an environment where you have the time and facilities and wish to take advantage of them. In my experience there is often a great deal of machinery and materials in schools, hospitals and day centres that is not used as there are no trained people for the job. But as I know you can soon instruct someone with the basic knowledge and desire to have a go, the most important thing to remember is that it is the people you are working with that matter and they would sooner work alongside you and learn with you than never have a go.

Making a Mould

1. To start, choose a simple design that does not have any undercuts, such as the cockerel that we made. Firstly, model the form as shown in Diagram 1. This has a base which could be a cardboard tube; it is there to make a reservoir for the liquid casting slip when you come to cast the piece.

2. Diagram 2 shows the front view of the cockerel and the centre line, leaving equal halves for the join of the mould and avoiding any undercuts.

3. Your original model can be biscuit fired and then well greased so that it comes easily out of the plaster of Paris mould. This can be difficult so you can use your leatherhard model, but you will have to take care not to damage it whilst making your mould.

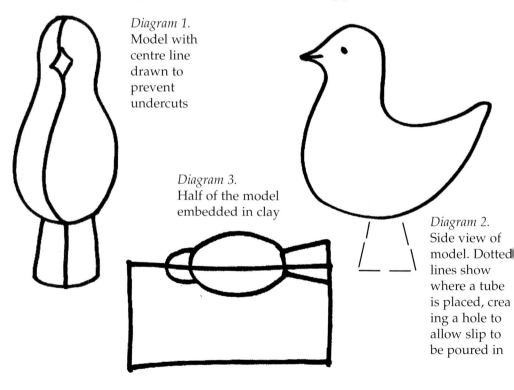

Diagram 1. Model with centre line drawn to prevent undercuts

Diagram 3. Half of the model embedded in clay

Diagram 2. Side view of model. Dotted lines show where a tube is placed, creaing a hole to allow slip to be poured in

I oil my models with an ordinary cooking oil to help them release from the plaster cast, but you can also use Vaseline.

4. To be able to make one side of the plaster mould you will need to embed your model in a bed of clay up to the centre line on your model (see Diagram 3). Make sure there is about 1 in. (2.5 cm) of clay between the mould and the surrounding board, and make sure that the boards you place around the slab of clay are very securely supported, so that the force of the plaster when poured in the box does not force out the sides of the box. The joins between the boards also need sealing so that the plaster cannot run out of any little gap (see Diagram 4). You can do this with clay.

5. You will need potter's plaster, which can be bought from most pottery suppliers, or plaster of Paris which is

Diagram 4. Seal gaps between boards with clay, and tie string tightly around top and bottom of box to take pressure of volume of wet plaster.

available from most chemists (see also Pottery Suppliers list on p.126). To mix the plaster you will have to judge the volume of space you will be filling, and you will need a large plastic container such as an old washing-up bowl.

6. The water is placed in the bowl first and the plaster sprinkled evenly over the surface of the water until the plaster is just sitting above the water level. Do not be tempted to stir the plaster until it is all added! Leave it for a minute to settle and then thoroughly stir, but do not whip it up, as you do not want to add air to the plaster mixture. The ratio of plaster to water is three parts plaster to two parts water, by weight.

7. When the plaster is creamy and thoroughly stirred, without lumps, you can pour it into your box and over the greased model, making sure that you are leaving no gaps or air bubbles around the model. There should be about 1 in. (2.5 cm) thickness of plaster covering the top of your model. Leave for about half an hour, or until hardened, before removing the casting box from around the model.

8. Remove all excess clay to reveal your model embedded in the plaster half. Into this needs to be cut some natches — the pottery term for locating lugs that will keep the two halves of the mould in the correct position when casting. These can be cut into the fairly soft plaster with the tip of a teaspoon, using a downward twisting motion to cut a 1 in. (2.5 cm) hollow into the plaster, as shown in Diagram 5.

9. The surface of the plaster now needs oiling with vegetable oil, so that when

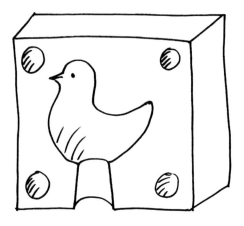

Diagram 5. Inside view of one side of plaster mould

the next layer of plaster is poured on it will release, when set, to create the other half of the mould. The oiling is very important so be diligent at this stage and check that every nook and cranny has been well oiled, as it is terrible to go to this amount of trouble only to find you cannot separate your model. I brush the oil over the surface and work it in well, then I repeat this to make sure, but there is no need to leave the surface swimming with oil.

10. Once the surface is oiled you can build up the box again (on the opposite side) and repeat the casting for the other half. After leaving for half an hour to set you can take the box away. You may have to try and prise the two halves apart to open the mould, but be very careful not to damage the joining surfaces of the mould or the inside. The model can be removed from the inside of the mould now, and the mould left to dry out for several days ready for slipcasting.

11. Make sure that no plaster gets into your clay supply, as it will blow apart in the kiln. The clay used for mould-making should only be used to make other moulds! Make sure no plaster gets into the sink, or it will cause expensive blockages. The best thing to do is to scoop out all the excess plaster from your plastic bucket while it is still soft, and put it straight into a dustbin (inside a bin bag). Then rinse the bucket out with as much running water as possible. A small amount of plaster well diluted should not block the sink.

Slipcasting

The mould is dry and ready for your first cast. The first cast is usually used to clean the mould and is not fired, as it tends to contain small amounts of plaster. The casting slip can be bought ready to use from a pottery supplier and usually comes with good instructions. If you have a blunger, and enough time however, you may want to make your own.

How to make casting slip

To do this well you will need a blunger. This process does take practice and you will have to do a bit of fine tuning until you learn how to recognise the correct consistency of the slip. If you do not have a blunger it is possible to make up small quantities by hand, but it is a very slow labour-intensive process. Ask the clay supplier for (a) the correct recipe for casting slip for your clay, (b) for the correct pint weight and (c) for the amount of time the slip should be left in the mould.

This will make about 5 gallons of slip.

1. Put 12 pints (6.8) litres of water into the blunger.

2. Add 2 oz (56.7 g) of sodium silicate (140° twaddle — this term is used for the strength of sodium silicate, pottery suppliers will recognise it).

3. Add 2 oz (56.7 g) of soda ash.

4. Start the blunger running.

5. Start cutting 1 in. (2.5 cm) thick slices of clay from a 25 kg bag of soft clay, and add them bit by bit. When the bag is finished, start on the next one doing the same. At this stage the slip should be fairly thin and smooth and as it gets to the correct consistency it starts to look glossy.

6. To see if the slip is ready, check the pint weight. Put a measuring jug on the scales, adjust the scales to zero, and then pour in the slip to exactly one pint. See what it weighs (mine is 35 oz/992.2 g), check against the fig-ure the suppliers have given you.

7. If the weight is a bit low add more clay leaving it to mix thoroughly before you weigh it. Be patient!

8. If the slip is too heavy or thick, try adding a small amount of water a bit at a time (100 ml/3.52 fl.oz at most to start). Do not add too much at once as the balance of the slip is easily upset. Another way to thin it down is to add a small amount of sodium silicate. The absolute maximum to add at a time is a teaspoonful (5 ml/0.176 fl.oz), as it is very powerful and could ruin the whole batch of slip.

9. The slip should now be ready for casting. When you open the tap on the blunger have a kitchen sieve ready over your bucket or bowl to keep any impurities out of the slip you are about to cast (you often find bits of wood or grit) as these will become part of the pot if they slip through.

10. Check your mould if it has more than one part, and make sure it is well bound together. Slip is very efficient at finding its way out of gaps and the weight of the slip will also push the mould apart. Ensure the mould is tightly bound using string with wedges under it, thick elastic bands, or the

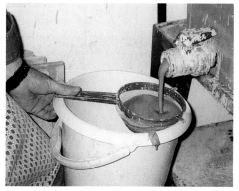

Once the slip is ready, sieve it into the bucket (see stage 9).

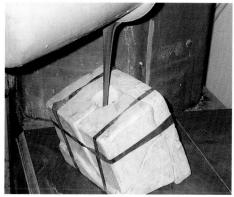

The slip is then poured into the tightly-bound mould (see stage 11).

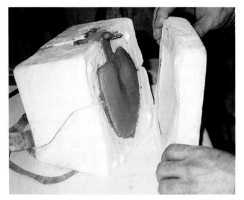

When the clay is leatherhard, the first piece of the mould can be taken off (see stage 14).

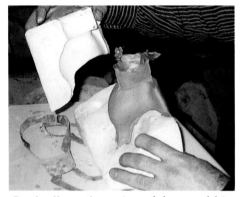

Gradually each section of the mould is removed (see stage 14).

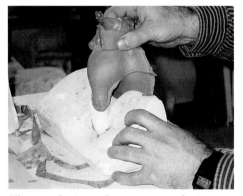

The cast being taken out, care being taken to handle it by the waste areas that will be cut off, to avoid damaging the cast (see stage 15).

elastic straps used for luggage.

11. Pour the slip into the mould, filling it to just below the top.

12. Time how long you leave the slip in the mould. I leave it in for about 45 minutes for stoneware, but clays can vary from 10 minutes to over an hour. The supplier should have the answer to this, and you can also experiment with different times. The resulting cast should be about ¼ in. (5 mm) thick.

13. After the allowed time, tip the excess liquid slip out of the mould and leave to drain at an angle back into the bucket. Draining on an angle will prevent stalactites of clay from forming inside your shape.

14. Leave the skin of clay in the mould to harden to leatherhard (this will take about half a day, depending on how dry the mould was). After this the mould can be undone carefully, and the cast removed.

15. Leave the cast to stiffen up further

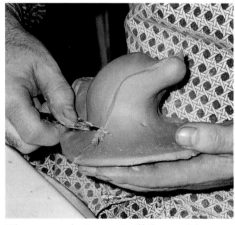

The seams being cut off the cast (see stage 15).

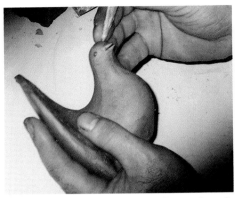

The eyes are marked in with a pointed tool on the cast of a bird, at stage 15.

until it can be handled without leaving dents. You can now trim off the lines left from where the mould joined, using a pottery knife or blade (I have an old hacksaw blade, filed down). This process of tidying up is known as fettling.

16. Let the pot stiffen up a little bit more (but not dry completely) before sponging down any rough areas.

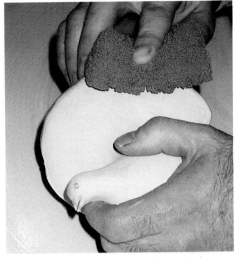

The edges being sponged, ready for the first firing. Take care, as the clay is very fragile at this time (see stage 16).

If you sponge it when it is too soft, it may deform with handling.

17. Allow the cast to dry out thoroughly before biscuit firing it (see p.27 for firing instructions).

7. Glazing and Decorating

If you want to buy your glazes ready-to-use there are a range of glazes called brush-on glazes, which exactly describes how they are applied. There are also ready-made glazes which you mix up and dip work into.

Safety Note: These substances can be extremely toxic and you must read the information thoroughly before use. It is important that you know your group well before you work with these products. This I cannot stress enough, as I well know how swiftly a person with learning disabilities can grab a paintbrush or a jar of something and devour the whole amount in no time. In this type of work there are a tremendous number of distractions that make it impossible to keep an eye on everyone all the time. The brush-on glazes are not always suitable for use on pots from which you eat and drink, another important aspect to consider.

I have always used stoneware glazes that have been made from my own recipes so that I know that they are safe for food use, that they will be fine in the oven, microwave and dishwasher, and that they are weatherproof. These are glazes that I use for my own work and I have had them tested up to British Standards. I include some recipes for you to try yourself, and the supplier that I use for the raw materials.

The other sort of ready-made glaze that you can buy comes in powder form and you mix it with water until it is the consistency of thin cream. This usually needs sieving through a 100 mesh sieve, unless stated otherwise by the manufacturer.

Safety Note: When mixing dry ingredients always add powder to water and work in a well-ventilated area. Wear a glaze mask if possible, if not then a dust mask, but be aware that the particle size of the dust is very fine and most ordinary masks do not give adequate protection. Be careful and do not take risks. Always follow instructions given with powders.

When you order your glazes or glaze ingredients, the manufacturer's catalogue will include good safety advice.

How to mix your own glaze

These instructions are to make up about 5 kg (11 lb) of dry glaze (about a two gallon bucket of glaze) there will be enough space at the top to allow for displacement when dipping your work.

You will need
• 100 mesh sieve (from pottery supplier)
• 2 large plastic containers or buckets (one needs airtight lid, to store glaze in)
• glaze or dust mask
• large stiff brush (washing up brush will do)
• water (and jug is useful)
• wooden slats
• pen

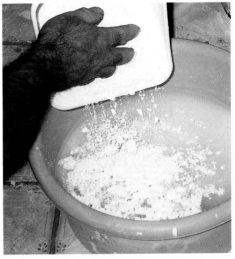

1. Almost half fill one of your buckets with water (always add the powder to the water as this helps prevent the dust going into the air and is better for your lungs). It also means there are less lumps to sieve out.

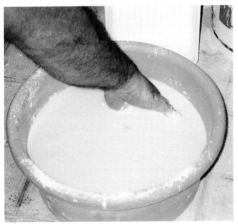

2. Add your own glaze ingredients, measuring each one and ticking it off your list to avoid a ruined batch of glaze. If you have glaze from a supplier, then simply add the contents to the water. Stir the wet mixture, adding water if necessary until your glaze mixture is a fairly thick creamy consistency.

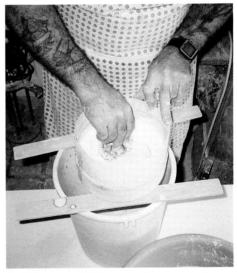

3. Take your 100 mesh sieve and place over the top of the bucket which is empty. If the sieve does not fit well, use a couple of strips of wood on top of the bucket, so you can balance your sieve steadily on top of them.

4. Pour about a pint (0.56 litres) into your sieve and then start working the glaze through the mesh into the bucket below. A large old paintbrush, or a rubber kidney from a pottery suppliers, or even an old credit card may help. Do not try to put too much glaze in the sieve at once as this will make it more difficult and glaze might spill over into the sieved bucket below.

5. Once sieved, you can adjust the glaze if necessary by adding water, until it is the consistency of single cream, and is ready to use.

Glaze will keep for a long time provided it is kept in a bucket with a sealed lid on, and is thoroughly stirred before use the next time. The glaze materials tend to settle at the bottom, so make sure the sludge at the bottom has been thoroughly stirred and lumps have dissolved again.

Tips
The pen is very handy to tick off each ingredient as you add it to the bucket, and finally to write the glaze on the bucket when you finish. It is very annoying to come back to glazes a few weeks later and not remember which is green and which is transparent!

Glaze Recipes
Below is a selection of my glaze recipes for you to try; the firing temperature is about 1250°–1260°C (2282°– 2300°F). They fire well in a gas or electric kiln. The measurements are given in grams, although any amount can be mixed, as long as the ratios remain the same.

These amounts of raw materials are easy to measure on domestic scales no longer used in the kitchen, but the metal oxides (those ingredients at the bottom of the recipes) need a finer and more accurate measure. Once you have weighed out your ingredients they can be added to water, thoroughly mixed and then sieved through a 100 mesh (available from pottery suppliers). I like to sieve the ingredients twice. See pp.118–20 for methods of glaze application.

Safety Note: Do this in a well-ventilated area and always wipe up spills of dry powder with a wet sponge or cloth so as not to create dust in the air.

There are very good books on glaze-making, if you enjoy this side of pottery. They are available in libraries or can be bought from pottery suppliers. A book I like to use is *Cooper's Book of Glaze Recipes* by Emmanuel Cooper. See also bibliography.

Transparent glaze	grams
Potash feldspar	2000
Whiting	800
Talc	100
Quartz	1500
China clay	500

Dark Green glaze

Potash feldspar	2,500
Whiting	375
Dolomite	750
China clay	250
Quartz	1,000
Copper carbonate	100

Mid-Blue Glaze

Potash feldspar	2,500
Whiting	375
Dolomite	750
China clay	250
Quartz	1,000
Cobalt Carbonate	25

Creamy White Glaze

Potash feldspar	2,500
Whiting	375
Dolomite	750
China clay	250
Quartz	1000
Titanium dioxide	500

Soft Brown Glaze

Potash feldspar	2,500
Whiting	375
Dolomite	750
China clay	250
Quartz	1,000
Red iron oxide	250

Slip Recipes

These slips are not the same as are used for joining your work together when making, or for slip casting. These slip recipes are purely for decoration, and techniques of applying them are given on pp.121–5.

These are made up in the same way as the glazes and applied to the leatherhard pot (before any firing!).

Mixing your own slip

Add the ingredients to very little water, stir and add water until thick cream. Then sieve through an 80s mesh if you have one. Add water to the slip until it is single cream consistency, or thinner (depending on how you want to use it, see methods of decorating with slip on pp.121–5).

	grams
White slip	
Borax frit	15
Nepheline syenite	30
Ball clay	30
China clay	15
Disperson (dispex)	10
Red/brown slip	
Ball clay	51
Flint	40
Crocus martis	9
Green slip	
Red clay	40
Ball clay	40
Flint	20
Copper carbonate	2.25
Chrome oxide	1
Blue slip	
Red clay	80
Flint	20
Cobalt oxide	1.5
Nickel oxide	1
Yellow slip	
Nepheline syenite	19
Feldspar	52
Yellow ochre	19
Ball clay	10
Crocus martis	8

Glazing and Decorating Methods

There are several ways to glaze your work once you have prepared the glaze. The three simplest methods are pouring, dipping and brushing-on.

Method 1. Pouring

1. A good even coating of glaze can be achieved by pouring glaze. Check for dust or loose bits of fired clay inside the pot, and shake them out away from the glaze. Try to avoid bits falling into the glaze as they will stick to the pot.

2. Remember to stir the glaze very thoroughly before you start. Fill up the inside of the pot with glaze from a plastic jug or something that pours well.

3. Turn the vessel upside down to empty out the glaze.

4. Before you glaze the outside of the pot, you may want to wipe off any dribbles with a damp sponge. To glaze the outside of the pot, hold the pot upside down and pour a steady stream of glaze from the jug over the pot, while also turning the pot around slowly, in order to make sure all areas are covered.

5. Finally, make sure you wipe all the glaze off the bottom of the pot with a damp sponge, otherwise it will stick to the kiln shelf, ruining both pot and shelf (shelves are expensive to replace). It is also wise to wipe the glaze off about ¼ in. (5mm) up the side.

Method 2. Dipping

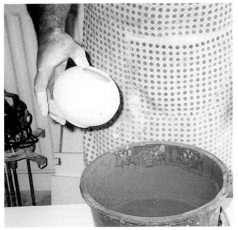

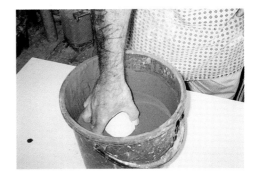

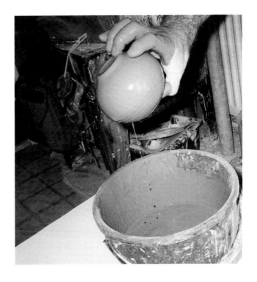

1. Before you start, give the glaze a good stir, make sure it is not too thick, and does not have big lumps at the bottom.

2. Holding the pot in one hand, in as few places as possible (a finger at top and bottom may be sufficient), immerse the pot in the glaze, allowing it to fill up inside.

3. Take the pot out of the glaze, turning it upside down to allow all glaze to drain out.

4. Place the pot on the work surface and take your hand away carefully.

Dip a finger into the glaze bucket and touch up the bare patches on the pot left by where your fingers held the pot.

5. With a damp sponge, wipe all glaze off the bottom of the pot, and ¼ in. (5mm) up the side to be safe.

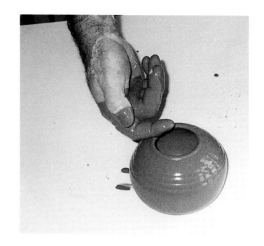

Method 3. Brushing

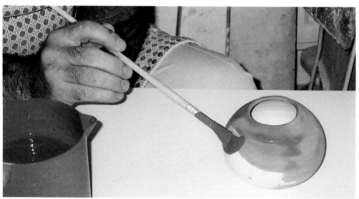

1. Using a long paint brush, brush the glaze onto the pot, holding it by the rim or by the inside and turning it around to make sure all areas are covered.

2. Once this is done, allow the glaze to soak in and dry, and then paint the inside of the pot. Take care when handling the glazed areas. This method is useful for anyone who only has the use of one hand. For some pots it may be easier for you to glaze the inside by the pouring method first, before painting the outside.

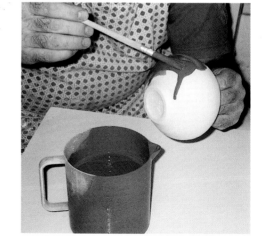

3. Do not paint the bottom of the pot. Remember to wipe any dribbles of glaze off the bottom and around the bottom edge with a damp sponge, so that the glaze does not run or stick to the kiln shelf.

Decorating With Slip

There are other ways to decorate the surface of your pot instead of with a coloured glaze. One of these is with slip, essentially a runny clay with different colourings added. This is not the same as slip used for slip casting, or for joining while making. Decorating slip is usually applied to the pot when it is leatherhard, as if the pot is any drier the slip can peel off the surface. You can buy ready made slip from a supplier, otherwise you can try some of the recipes listed on p.117. All slip decoration can be glazed after the biscuit firing. A clear glaze is usually best to show the pattern clearly, although semi-transparent glazes can give a subtle effect. This will then make it more durable and waterproof.

Slip trailing

1. For this you will need a special slip trailer (bought from pottery suppliers). It looks like an old bulbous rubber bicycle horn, with a fat body and a thin nozzle. To fill it up, squeeze most of the air out, dip the nozzle into the slip (runny slip is easier) and gradually release your grip on the body until it sucks up a good quantity of slip. After loading up the trailer, you may want to wipe the end of the nozzle of slip dribbles in order to get a clean line.

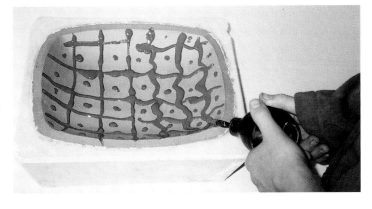

2. To decorate, put the nozzle of the trailer against the side of the pot, and gently squeeze while using the trailer like a large marker pen.

 This technique is great for patterns, chequers, dots or wavey lines, but is actually much harder than it sounds to do well, and it is worth rolling out a few slabs to practice on, or even practising on a table. It may help to pencil out the decoration and then follow it.

Sgraffito

1. Paint on a layer of slip onto the leatherhard surface and allow it to dry a little and harden up (you will see the pot soak it up). You can alternatively dip the pot into a bucket of slip if you have enough, but beware as pots often collapse or distort doing this. They will soak up the moisture and revert to their soft clay state.

2. Then take anything sharp, such as a potters needle, or something with a fine point (an old pen nib, a sharp stick, or a comb or fork are fine) and draw/scratch through the slip to the surface of the clay below.

 For complicated patterns or drawings you can lightly pencil the image onto the slip when it is firmer before scratching through your final marks. This works well with contrasting colours, such as white slip on red clay. For practice, or for those who enjoy the design side more, you can roll out some slabs to practice on.

Paper resist

1. For bold simple shapes and patterns, this is very effective and easy. First, cut out your shapes from newspaper.

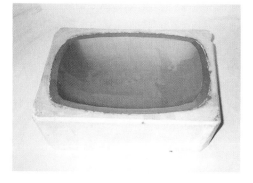

2. Dip each shape into a bowl of water briefly, and then wipe it gently on the edge of the bowl to remove the excess water from the paper.

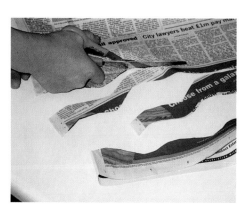

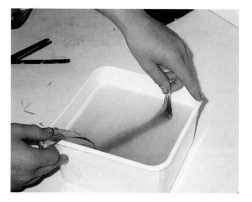

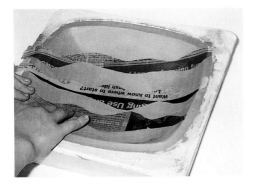

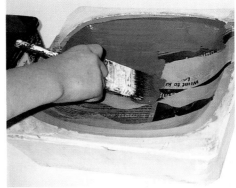

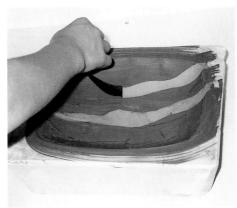

3. Lay the shape on your work and smooth down lightly with your fingers until it has stuck to the dish. Make sure the edges are down but not too embedded in the clay if possible. The newspaper acts as a mask from the slip.

4. Using a large soft brush, paint the slip over the top to cover the whole surface (clay and paper) of the dish.

5. Once the slip has dried, you can just peel off the newspaper gently. If you have trouble picking up the edges of the paper, take a needle and gently lift a corner until you get a good edge to grip.

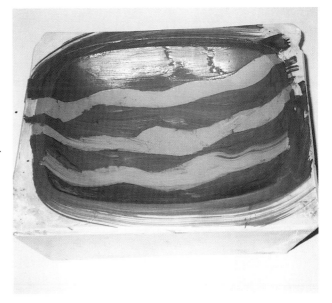

Sponging

This can be done in a very precise way with neatly cut synthetic sponges, or in a much more random and subtle way with a small natural sponge.

1. Make sure your slip (you can also glaze with this method) is well stirred, as the sponge will only pick up the surface of the slip. Often the heavier materials will sink, leaving you with just water at the surface, so it is important to stir well. It helps if the slip is slightly thicker with this method.

2. Squeeze any water out of your sponge first, and then dip the sponge into the slip and apply gently to your work. Experience and practice will teach you to perfect this technique.

Synthetic sponges can be cut into specific shapes for students to use (for example flowers, ducks, or simply circles and triangles). With a natural sponge, you get a dappled effect, and you can use several different colours on top of each other to create different effects (let each layer dry before adding the next).

Marbling

This is a technique best used on dishes.

1. Pour a small amount of two different coloured slips onto your dish and then twist or shake the dish to make the two slips swirl together in different patterns.

It is sometimes easy to overdo this and end up with a muddy pool. Wipe out the dish with a rubber kidney and try again, or if you are feeling brave, rinse it off, and then leave the dish to firm up again before another try.

Combing

Again, this works best on dishes.

1. Paint a layer of slip in the dish while it is still damp, and then draw your fingers through it to reveal the colour of the pot beneath, creating a bold pattern. You can also use an implement to create the combing, or cut your own from stiff card.

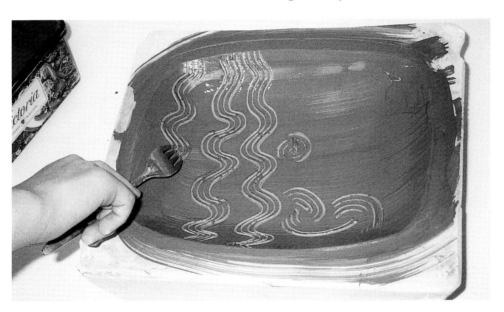

Freehand

Slip can simply be painted straight on to the pot to create drawings or abstract designs. You can also flick slip at your work creating random patterns (try using a toothbrush). It is good to get people to experiment and see what surprises this brings.

With all of these ideas, glazing the work with a clear glaze afterwards will bring out the colours of the slip and make the work more durable.

Pottery Suppliers

The main pottery suppliers I use are:

Potterycrafts
Campbell Road, Stoke-on-Trent,
ST4 4ET
tel: 01782 745000, fax: 01782 746000.

Les Bainbridge
The Crescent, Heath Grove,
Logger Heads,
Market Drayton, TF9 4PE
tel/fax: 01630 673762.

Spencroft Clays
Spencroft Road,
Holditch Industrial Estate,
Newcastle, Staffs. ST5 9JB
tel: 01782 627004, fax: 01782 711395.

When I worked for local authorities I was able to order clay and certain materials through them, but I found that the suppliers listed above provided me with a better selection.

Other U.K. suppliers are:

Bath Potters Supplies
2 Dorset Close,
Bath BA2 3RF
tel: 01225 337046, fax:01225 462712

Briar Wheels & Supplies
Whitsbury Road, Fordingbridge,
Hampshire SP6 1NQ
tel: 01425 652991

Brick House Ceramic Supplies
The Barns, Sheepcote Farm,
Sheepcote Lane, Silverend, Witham,
Essex CM8 3PJ
tel: 01376 585655

Ceramatech Ltd.
Units 16 & 17 Frontier Works,
33 Queen Street, London N17 8JA
tel: 020 8885, fax: 020 8365 1563

Clayman
Morells Barn, Park Lane, Chichester,
West Sussex, PO20 6LR
tel: 01243 265845, fax: 01243 267582

K.F.S. Acme Marls Ltd.
Bournes Bank, Burslem,
Stoke-on-Trent, Staffs. ST6 3DW
tel. 01782 577757

Potclays Ltd.
Brickkiln Lane, Etruria,
Stoke-on-Trent, ST4 7BP
tel: 01782 219816

WJ Doble Pottery Clays
Newdowns Sand & Clay Pits,
St. Agnes, Cornwall, TR5 0ST
tel: 01872 552979

Valentine Clay Products
The Slip House, Birches Head Road,
Hanley, Stoke-on-Trent, Staffs. ST1 6LH
tel: 01782 280008

North American Suppliers:

American Art Clay Company
4717, W. 16th Street,
Indianapolis IN 46222, USA
tel: 317 244 6871

Axner Pottery Supply
P.O. Box1484, Oviedo,
Florida 32765, USA
tel: 800 843 7057

Continental Clay Company
1101 Stinson Blvd, N.E.,
Minneapolis MN 55413, USA
tel: 612 331 9332

Laguna Clay Company
14400 Lomitas Avenue,
City of Industry, CA 91746, USA
tel: 800 452 4862

Mile Hi Ceramics
77 Lipan, Denver, Colorado
80223-1580, USA
tel: 800 456 0163

Minnesota Clay Co.
8001 Grand Avenue South,
Bloomington MN 55420, USA
tel: 612884 9101

Tucker's Pottery Supplies Inc.
15 West Pearce Street,
Unit 7, Richmond Hill,
Ontario, L4B 1H6, Canada
tel: 800 304 6185

The Potters Shop
31 Thorpe Road, Needham Heights,
MA 02194, USA
tel: 781 449 7687

Bibliography

Cooper, Emmanuel *Coopers Book of Glaze Recipes* Batsford Ltd.,
London, 1987
(Currently out of print, new edition forthcoming from A & C Black)

Flight, Graham *Ceramics Manual* Collins Sons & Co. Ltd.,
London, Glasgow, Sydney, Auckland, Johannesburg, 1990

Minogue, Coll *Impressed and Incised* A & C Black, London, 1996

Potter, Tony *Usborne Guide to Pottery* Usborne Publishing,
London, 1985

Wren, Rosemary *Animal Forms and Figures* Batsford Ltd.,
 London 1990

Index